Print Matters
THE KENNETH E. TYLER GIFT

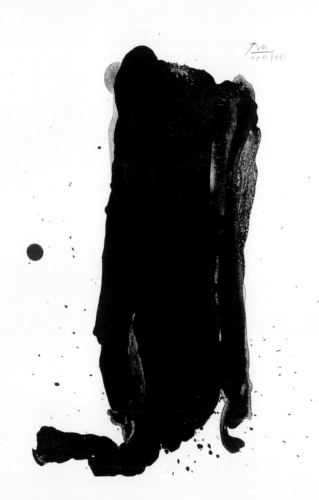

Edited by Sean Rainbird
With an essay by Pat Gilmour

Print Matters

THE KENNETH E. TYLER GIFT

Tate Publishing

First published 2004 by order of the Tate Trustees
to accompany displays at Tate Modern (Nov. 2004–April 2005)
and Tate Liverpool (Nov. 2004–March 2005)
by Tate Publishing, a division of Tate Enterprises Ltd,
Millbank, London SW1P 4RG
www.tate.org.uk/publishing

British Library Cataloguing in Publication Data
A catalogue record for this book is available from
the British Library

ISBN 1 85437 558 X (pbk)

Distributed in the United States and Canada by
Harry N. Abrams, Inc., New York

Library of Congress Cataloging in Publication Data
Library of Congress Control Number
2004111325

Designed by Philip Lewis
Printed by Conti Tipocolor, Italy

Cover: James Rosenquist, *Time Door Time D'Or* 1989
(detail of no.41)
Frontispiece: Robert Motherwell, *Brushstroke* 1980

Measurements of artworks are given in millimetres,
height before width

Contents

Foreword

This publication celebrates a magnificent gift of some 450 prints made over the past thirty years. It is the most substantial donation to Tate's collection of prints since it was established in 1975. Then it was the result of many gifts channelled through the Institute of Contemporary Prints (ICP) as a conduit for forming a collection of prints at the Tate Gallery. Among the gifts there were three main groups; from Rose and Chris Prater's Kelpra studio, from the Curwen Press, and from Leslie Waddington and Alan Cristea at Waddington Graphics. The present donation brings for the first time to a public collection in Europe the achievement of Kenneth E. Tyler, one of the most remarkable printmakers and publishers in the history of contemporary prints. Moreover, his impeccable documentation and provision of full and accurate information has made the physical transfer of the gift to Tate characteristically well planned and exceptionally smooth.

It is entirely fitting, too, that Tyler has made this extraordinary gift in recognition of Pat Gilmour. Gilmour has known Tyler for over three decades and has written extensively about his workshop and the artists he has published. She was the inaugural curator of the Print Department at what was then the Tate Gallery, before moving in the mid-1970s to continue her career in Australia. Her encyclopaedic knowledge about the medium and her passionate advocacy in fostering wider understanding about, and appreciation for, prints has been a constant throughout a long and distinguished curatorial career.

Ken Tyler began his training at the Tamarind Lithography Workshop in Los Angeles. Set up in 1960, June Wayne transformed the recent tradition of American printmaking from making small, inexpensive and often technically deficient images in woodcut, etching or lithography, into a highly developed medium. Like many of his generation Tyler's first expertise was in lithography. He advanced to become master printer at the Tamarind Workshop before setting up on his own as Gemini GEL. Soon adding and combining other print media with lithography he became one of the most brilliant of a generation of printmakers and publishers. Tyler forged ambitious collaborations with artists and fully exploited the potential of the different print media. He has said that his private research projects and periods of experimentation with artists often happened in parallel, with each informing and enriching the possibilities of the other. Tyler worked with many of the most gifted artists of our times. His technical expertise, willingness to experiment, commercial adventurousness and his creative engagement with artists enabled

him to print and publish some of the most ambitious and accomplished multiples and editioned works of the past four decades.

In 1974 he moved to the East Coast, setting up in Bedford, Connecticut, before, in 1986 moving Tyler Graphics Limited to Mount Kisco, north of New York. During this period Tyler experimented intensively with paper-making, as well as expanding the boundaries of printmaking. He kept a wider range of colours than any other print workshop and acquired some of the largest, most advanced printing presses. He reorganised his staff to move beyond expertise in a particular medium, the traditional pattern of print workshops, so that they could offer all round support in their collaborations with artists. On the East Coast Tyler continued working with artists with whom he had collaborated since the 1960s. He also forged new relationships with both established and emerging artists. This introduced new ways of working but also set new technical and stylistic demands.

While Ken Tyler has been at the forefront in the renaissance of printmaking in America over the past four decades, the growing sophistication and cost of modern prints has made it increasingly difficult for public institutions to form coherent and representative collections.

With this magnificent gift, which augments prints from Tyler's period in Los Angeles already in the collection, Tate, of all museums in Europe, can now claim to have unparalleled holdings of masterpieces of printmaking from the late twentieth century by one of America's master printmakers and publishers. For this we owe Ken Tyler our profound gratitude.

At Tate many colleagues have been involved in the acquisition of this extraordinary gift: registrars led by Rosa Bacile; works on paper conservators led by Calvin Winner, assisted by Kate Jennings; Sarah Taft, formerly of the Tate print room and Sean Rainbird, Christine Kurpiel and Alison Duke who coordinated the acquisition from the Collections curatorial department. Many staff have been involved in the preparation of this publication celebrating Ken Tyler's gift; Mary Richards, project editor, and Tim Holton, production, at Tate Publishing, David Clarke and his team in Photography, Sean Rainbird, for his interview with Tyler, Helen Delaney and Kathryn Rattee for their commentaries on many of the artists, Federica Panicieri and Rachel Taylor for contributing biographies and a select bibliography.

Nicholas Serota
DIRECTOR, TATE

Ken Tyler proofing Helen
Frankenthaler's lithograph
Reflections XI, February 1995

The Ken Tyler Gift: artists in print

Pat Gilmour

I did not think the day would ever dawn when Kenneth E. Tyler – a printer of legend – would lay down his roller and repair to his farm. Now the moment has arrived, Tyler has marked his retirement with a generous gift to the Tate.[1] It includes some of the most spectacular prints on which he collaborated, during the last phase of his extraordinary career.

As the Founding Curator of Prints, responsible to Sir Norman Reid during the early 1970s, I set up the Gallery's first print department. Although it no longer ignored printed art, only works by British artists were collected and even these were acquired by persuading publishers and artists to donate them. The collection consequently took the form of a quasi *dépôt-légal*.[2]

One morning, having an imminent exhibition to prepare, I arrived for work at 3am. To my dismay, the gates on Atterbury Street were locked, barring my way to the staff entrance. Only by throwing gravel at the door was I able to attract the night porter's attention and ask him to let me in.

Some years later, the Tate's Head of Education joined the staff of the nascent National Gallery in Australia. It was due to open in the Fall of 1982 – England's Autumn, Australia's Spring. When my former colleague told the Director in Canberra that I once arrived for work in the middle of the night, he invited me to Australia for an interview. Although it seemed unlikely that my family would emigrate, having been to the Antipodes in my youth I was curious to see how the place had changed. As it transpired, the new department not only received a generous allocation for prints, but my family was keen to go. Just think! Had I not thrown grit at the Tate that night, I might never have met *Ken Tyler: Master Printer*.[3]

Some time before I went to Canberra,[4] Tyler left his Los Angeles workshop to set up another in the East. To finance this move, he sold some 600 prints to Australia. Although the prints he produced on the West Coast were criticised in the East, they included some magnificent images. Among them were such suites as Jasper Johns's *Color Numerals*, Robert Rauschenberg's *Stoned Moon Series* and work by Roy Lichtenstein entitled *Peace Through Chemistry*. When Tyler later moved east, he published many other outstanding prints – *The Gray Instrumentation Series* by Josef Albers, Helen Frankenthaler's *Essence Mulberry*, David Hockney's *Paper Pools* and last, but not least, *Talladega Three II* and *Pergusa Three Double* from Frank Stella's colourful *Circuits*.[5]

As Head of the Australian National Gallery's collection of International Prints and Illustrated Books, I travelled extensively, not only to buy art, but to interview artists and publishers. I don't have the slightest idea how many times I circumnavigated the globe, but whenever I went to America, I visited Tyler to look at his recent productions.

Son of a Hungarian steel worker, Tyler grew up in Chicago. He was thirty-two years old before he discovered his vocation, although he had always been interested in art. To earn a few dollars as a student, he matted works for the local museum. His mentors included Garo Antreasian and William Crutchfield, who taught at the Herron School of Art.[6] Indeed, during the late 1970s, Tyler published Crutchfield's whimsical trains. Of those included in his gift, one emits smoke in the form of square stones, two engage in a boxing match on a rickety bridge, while the third – marooned on a bank of sand – awaits its burial at sea.

Following army service during the Korean War, Tyler received a grant from the Ford Foundation, which entitled him to study at the Tamarind Lithography Workshop, set up and run by June Wayne. Wayne once wittily observed that when first she became interested in prints, the images then being made in America 'put her in mind of dead mice'. Later, she persuaded the Ford Foundation to bankroll an American workshop, where printers could collaborate with artists.

1 Tyler's recent gifts to collections in the northern hemisphere included the Addison Gallery of American Art, Andover, Mass., the Metropolitan Museum of Art, New York, and the Tate Gallery, London. The gifts were made in honour of Frank Stella, William Lieberman and Pat Gilmour.

2 In France, the law requires an impression of each print to be deposited at the Bibliothèque nationale. In England, the legal requirement does not cover prints, but every book must be deposited with the British Library.

3 This was the title of a book about Tyler that I was asked to write in six weeks. The Director, James Mollison, who set up the Gallery from scratch, acquired art by bulk buying – including Tyler's production at Gemini GEL (Graphic Editions Ltd), Los Angeles.

4 Canberra was a bizarre choice as the Capital of Australia, but as Sydney and Melbourne couldn't agree, the Australian Capital Territory (ACT) was created half way between them, in the Bush. When I was working in Australia, the situation was risible. On one occasion my plane attempted to land three times, then had to return to Sydney for fuel. There was a kangaroo on the runway!

5 I brought in *Pergusa Three Double*, intending to buy it, but Tyler was so pleased with the Print Department's exhibition and my book *Ken Tyler: Master Printer*, that he gave the print to the Gallery, rather than selling it.

6 Tyler received a Master of Art Education Degree at Herron School of Art.

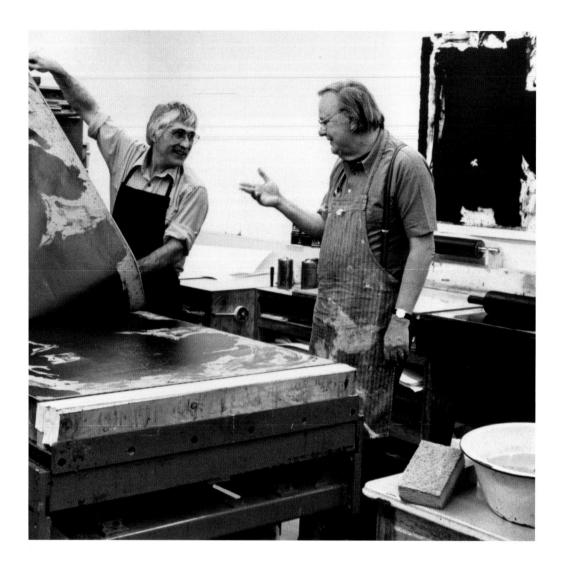

Robert Motherwell discussing *Lament for Lorca* with Ken Tyler as he pulls an impression in the press room at Bedford Village, New York, in 1983

Tyler made several friends at Tamarind. He met Marcel Durassier, Wayne's French lithographer, and the artist Josef Albers. Durassier was a character. As well as printing Wayne's book, he realised several prints for Picasso at Mourlot's lithography workshop in Paris. When the artist offered him two proofs, appalled by the liberties he took, the printer tore them to bits in his presence. On the other hand, Durassier paid Tyler the ultimate compliment. He made him a gift of his roller.[7]

Tyler named his first workshop Gemini, after the heavenly twins. They stood for grease and water – the essentials of lithography. Although he understood it was his job to carry out technical requirements, Tyler also saw the theatrical side of printmaking. While he felt it appropriate to orchestrate events and to ensure that the artist was comfortable, he adopted the credo: 'I do not intrude into the business of making art. I simply do whatever I have to do to serve the artist.'

Among the tasks for which Tyler did assume responsibility was the acquisition of ever larger presses and ever larger sheets of paper. Eventually he made the paper himself. He wanted prints to be so credible 'that once you had spent $3000 you couldn't throw a print away, you couldn't give it away, you couldn't put it in the closet, you had to hang it! And once it was hung, you were hooked!'

7 In November 1963, Tyler made nine pages of detailed 'Notes and Observations' based on conversations with Durassier. Among the Frenchman's tips and wrinkles was the advice to use the thin bone of a turkey's leg when drawing with lye and acid, and the need for a printer to deploy his roller 'with great love'.

Although the names of the artists in Tyler's gift do not utilise every letter in the alphabet, they come close. Ed Baynard interpreted flowers in vases by utilising different woods. His *Tulip Pitcher* rejoices in a Russian plywood, while he used fir, pine, walnut and mahogany for other vessels. The Norwegian Per Inge Bjørlo reveals a very different temperament. Working with Tyler on *Heads from Balance* helped him to leave a difficult childhood behind him. Some of his linocuts put one in mind of his Norwegian compatriot – the sculptor, Gustav Vigeland, while Stanley Boxer, musically inclined, bases one suite on 'The Carnival of the Animals' by Saint-Saëns. Employing every intaglio technique, he also hand-inked and printed the plate. Then, scoring a vestigial image on Plexiglas, he printed it in the margins. In a second suite, Boxer invented some ingenious titles by stringing several words together – *Amissinamist* and *Curiousstalking*, for example. These intriguing subjects were coloured by finger and brush, using innumerable inks and watercolours.

Two of Anthony Caro's pristine paperworks in the gift were created simply by folding paper, while he mounted other vividly coloured forms like sculptures on a plinth. Mark di Suvero's reputation is based on his huge steel sculptures, equipped with moving parts. The lithograph, *Tetra*, is closely related to these.

Day One, the earliest work by Helen Frankenthaler included in the gift, recalls God's command in Genesis: 'Let there be light!' She is also represented by three subtly expressed lithographs – *All About Blue, Mirabelle*, and *Madame de Pompadour*. Among the artist's other works is a delectable artist's book in a narrow, horizontal format. Although the title claims *This Is Not A Book*, its first leaf is inscribed *A Page From A Book I*. Make what you like of that!

Richard Hamilton's fruits and flowers, set beside a toilet roll, have been described as 'challenging'.

When people called his work obscene, the artist explained that he was questioning 'an absurdly sentimental statement'. Indeed, blooms evoke fine feelings, ordure is down to earth and the toilet roll is advertising, so the print is defined as Pop art! In his second interpretation of the subject – an exquisite monochrome beach scene – two seal pups frolic in the twilight. Well! That's how Ken Tyler described them . . .

The first prints that Michael Heizer made were based on the analysis of a circle, although the artist is best known for his monumental earthworks, constructed during the 1960s. Twenty years later, in 1983, Heizer realised two brilliantly colourful prints. The first, *Dragged Mass*, records a protest staged by the artist at the Detroit Museum of Art in 1971. As a metaphor for the slaughter inflicted during the Vietnam war, he dragged a thirty ton stone back and forth across the grass. Heizer's second project, *Levitated Mass*, was the name he gave to a fountain, made for IBM, New York, in which a vast stone appears to be floating in the water. The artist's technicolour print reveals the secret of the fountain's ingenious construction.

Al Held draws geometric forms in brilliant primary colours. His bold rings, prisms and shapes – open rather than solid – are complemented by delicate pastel backgrounds, ranging from pale pink to mist grey. David Hockney is represented by a paper pool, *Pool II-D*. It is closely related to a group made twenty years earlier, literally entitled: *Lithographic water made of crayon and two blue washes*.[8]

Collage was often an element in Ellsworth Kelly's work and *Saint Martin Landscape* stems from an image of postcard size, realised during the 1950s. Since then, the artist's figure/landscape has undergone a dramatic shift in scale. A much larger torso now extends across a much larger page.

Terence La Noue – one of America's fascinating postmodernists – combines a surprising variety

8 As the Tate is well endowed with Hockney prints, Tyler donated one the Gallery did not already possess.

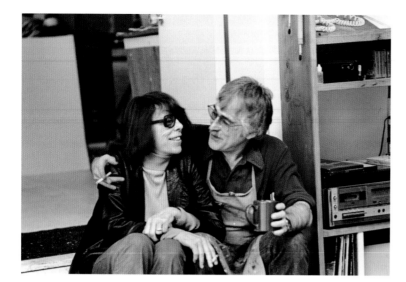

Joan Mitchell and Ken Tyler
in the artist's studio at
Bedford Village, New York, 1991

of images, borrowed from archaic cultures. In *The Sorcerer's Apprentice,* for example, pictographic figures levitate on a dark sandblasted plate, edged with multicoloured squares, while his *Ritual Series* boasts every colour, every technique and every style, from Byzantium to the African Bush.

The prints made by Roy Lichtenstein include *Reflections on Brushstrokes* and *Reflections on Hair*. In his *catalogue raisonné*, the artist expressed particular approval of his brushstroke reflections. Although fictive, they represent paint, glass, the texture of canvas, as well as the sweep of the brush. 'It touches on all that is art – more or less,' said the artist. Another print, imposed from hand carved woodblocks, comes from his *American Indian Series*.

After meeting the Abstract Expressionists, *c.*1950, the artist Joan Mitchell followed in their footsteps. Seven years later, Irving Sandler, historian of the movement, in poetic mood, suggested that the light emanating from Mitchell's landscapes had been sifted through 'an exultant memory'. The artist died in 1992, but her lyrical calligraphies continue to conjure up the fields, flowers, weeds and trees that she drew near her home in Vértheuil.

Robert Motherwell's love of black was legendary. At his Madrid retrospective, he was astonished when – like a Shakespearean actor – the Spanish poet Rafael Alberti declaimed a poem in his honour called *El Negro Motherwell* (Motherwell's Black). A book the artist later made includes the images *Black Undone by Tears, Through Black Emerge Purified* and *Black with No Way Out*. This last print, close to a metre in width, is a very large print to include in a book.

Tyler's gift also features Motherwell's *America – La France Variations*. The title is taken from labels used by a French manufacturer of paper for fine art. Describing Tyler – who lived next door to him – as 'the greatest technical genius in America', the artist once informed an audience that the Sunday afternoons he spent with the printer were 'among the happiest of my life'.

The British artist Malcolm Morley delights in the outdoors. His typical subjects include beach scenes where yachts and parasailors scud before the wind. He is also fond of depicting life on the farm, with Devonshire cows in the field, horses on the hill and goats in the shed.

At one time, John Newman longed to be a poet. After a Constructivist interlude, however, he turned to forms 'very much of the world'. According to the writer Adam D. Weinberg, Newman is a remarkable polymath, able competently to discuss biological, mathematical and linguistic theories. In his latest prints, a set of linocuts called *Second Thoughts*, Weinberg identifies forms ranging from Celtic manuscripts and Tibetan mandalas to the inventions of Rube Goldberg. Newman is equally fascinated by toroidal and topological shapes. Despite his learning, Weinberg claims

that the artist's most recent prints are 'deceptively and disarmingly simple'.

In 1992, the prints made by Hugh O'Donnell stemmed from a poetic wish to be in harmony with the elements and to become 'vertical water'. His outsize print, called *Waccabuc I*, was inspired by a lake in central Connecticut. As well as printing in colour, he also coloured the sheet by hand.

Although a newcomer to making prints, Sam Posey has many other talents. According to Tyler, they influence his printmaking. He is a professional racing car driver, a designer, an author as well as an award-winning broadcaster. The first three prints he made were *Artist and Model*, *Goodbye Kisco Avenue* and *Odyssey*.

One of Tyler's many gifts has been an ability to design extremely sophisticated presses. One, a Siamese construction, was nick-named *Double Trouble* by James Rosenquist, as it was capable of printing both lithographs and intaglio prints from the same surface. Tyler also acquired an offset press, ideally suited to print the collage elements in *Time Dust*. This vast image measured close to eleven metres in width.[9]

In her monograph about the former sign-painter, Constance Glenn talks of Rosenquist's 'meteoric rise to fame'. This is an unfortunate metaphor, as meteors don't rise, they fall to earth and burn out. It would have been more appropriate to say that his career took off like a rocket! The artist certainly thought BIG, and when he and Tyler worked together, measurement knew no bounds. Describing the making of *Time Dust*, with its witty flotilla of pencils, the artist explained: 'My project with Ken began as a sketch for this huge, huge work, which is about the garbage left in space.' As Tyler has always burned with the desire to increase the size of prints, Rosenquist's work was right up his street. As a sign painter, he once climbed scaffolds to paint whisky bottles 'larger than ranch houses'.

Time Dust is not merely big, it is huge and, so far as I know, it is the largest artist's print ever made. When he read about this mammoth image, Philip Larson declared: 'Printmaking has invaded the territory of painting! Two hundred and fifty square feet of hand-made paper, demand new ways of discussing Rosenquist's art.'[10]

Other arresting images by the artist include *Time Door, Time d'Or* – exotic flowers against a ruby sky, punctuated by stars – and *Sun Sets on the Time Zone*. This lithographic print, with slivers of eyes and flesh adjacent to the mechanism of a watch, warns us that time is running out. Rosenquist isn't an artist who merely thinks big; he is concerned about the stability of the world and the way human beings treat it.

David Salle is a postmodernist who, in a way recalling Surrealism, juxtaposes unconnected things. He is represented by five prints from the suite *High and Low*. Indeed, the titles mostly deal with dimensions, combining such words as 'high', 'long', 'wide', 'low', 'up' and 'down'. Then suddenly, another image is defined by speed. The pictorial content is just as confusing, as logic is inapplicable. Is *Long and Narrow* longer or narrower than the others? No! Is *High and Wide* higher or wider than the others? Well . . . not if viewed in the same orientation. Does anything move swiftly in *Fast and Slow*? If it does, the movement is invisible. However assiduously one identifies the multifarious images Salle made, they take the viewer nowhere. But my word! The journey is fascinating.

In *Time Magazine*, Robert Hughes once wrote that some critics thought of Alan Shields 'as a crafty sixties *bricoleur*, fiddling with mandalas by the seaside'. In fact, close to two metres tall, with a shaven head and a nautical beard, Shields stitched his canvases together on a sewing machine. When he began to work with art on paper, he stitched that on a sewing machine as well! *Odd-Job* and *Bull-Pen* have lattice strings ingeniously

9 In its simplest form, lithography involves drawing on limestone with grease. The grease is coloured black, so the artist can see the drawing. The printer then washes out the colour, leaving only the grease to be absorbed by the stone. In direct lithography, the image is reversed during printing, but if a transfer lithograph is used, the image is set down back to front. When printed, it is realised in its correct orientation.
10 *Time Dust: Complete Graphics 1962–1992*, New York 1993.

interposed with a variety of handmade papers. To suggest an image inspired by a woodcock, Shields, from his lofty height, rained down coloured spots with an eye dropper.

The British artist Richard Smith named his aquatinted *Fields and Streams* after English places. Apart from *Double Meadow* – which is clearly a field – the quaint names *Ick, Pix, Ouse* and *Cam* refer to the tributaries of English rivers. Smith's use of aquatint proved exquisitely appropriate – the rivulets of colour flow down the page.

T.S. Solien deals with myths. Combining relief with intaglio, one of his images deals with *Psyche*, whose emblem is a bird, the other refers to *Excalibur*, King Arthur's sword.

Tyler recalls that when Steven Sorman first came to his workshop, he was 'like a kid in a candy store'. For his part, the artist remembers having 'respect and awe' for the printer, regarding his work as 'the best of the best'. Spending time in his workshop, he said, was akin to 'experiencing a tornado'.

To avoid going to work empty-handed, before making prints with Tyler, Sorman snapped his wife Melissa standing on one leg. Later he made both a plate and a woodblock of her image. In the prints of 1985 we find Melissa's leg recurring. It appears both in *Now At First and When* and *Years and When*. Sorman also found a use for some intriguing readymades. They included a hand from a Burmese sculpture, and a curved wooden shape. The latter fell from his porch one morning as he left for work.

Three years later, Sorman's screen was one of the most inventive to come from Tyler's shop. Suggesting night and day, the imagery on one side, of leaves, tendrils and stems, is sunlit. The other side, rich blue and black, is worked with evocative lines, which suggest Matissean figures dancing. Later, the screen's coiled and spiralling shapes were developed by Sorman into a suite called *those from away*. Each image consists of two

sheets of paper, one vertical, the other displaced. *dwarf of itself*, is a five-colour mezzotint, roughened by carborundum. Sorman also mezzotinted an artist's book, to illuminate three poems. This technique is exhausting, demanding endless repetitive movements, which add up to considerable strain on an artist's hand.

When I interviewed Sorman in July 1989, he said that some artists viewed Ken as a person

> who comes along and twists your arm, and you do Ken Tyler prints. That's bullshit! Ken is a tough guy, but he also knows how to listen. I never felt for one minute that I had to do something to please him. You can't come in and be a mouse. When he asks what you think, you'd better have an opinion. *He* certainly does! But it's a very generous open-ended situation here.

As chance would have it, the gift to the Tate includes two artists called Sultan, although they are poles apart, both in content and in style. Altoon Sultan, who hails from New Zealand, drew some exquisitely delicate drypoints featuring her country. She continued to use the technique when she moved to America. Donald Sultan is a very different case. In his spoof, he employs the conventions of technical drawing to record common objects. *Eight Ball* – a ball you do not get behind if you fancy your chances playing pool – is depicted as a black circle bearing the figure eight. As to the protractor of 360 degrees, perhaps it helps the player to cue the ball in the right direction. On the other hand, perhaps it doesn't. *Butterfly* isn't a ball game at all. Nevertheless, Sultan has measured seven examples of the species – including a dead one! The orange, a fruit, is even more amusing. As an observer might expect, the bottom view, the side view, the top view, the interior view – even the black silhouette – is circular. Only a segment (with a pip!) offers a different shape. Finally, we come to

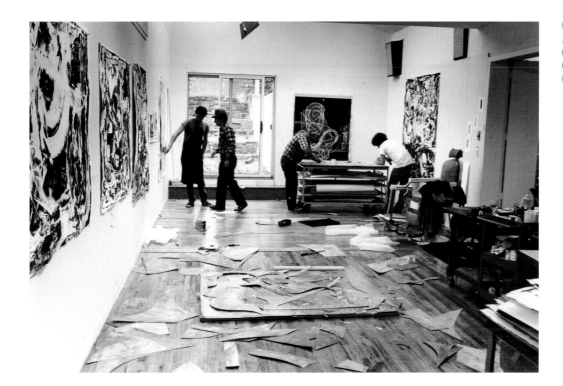

Frank Stella working on the *Swan Engravings* series with Ken Tyler assisted by Rodney Konopaki and Bob Cross, Fall 1981, Tyler Graphics Ltd

the button. Drawn on the first day of March 1996, it might have been even more amusing, had it been drawn on the first day of April.

The path jointly taken by Tyler and Frank Stella has proved an extraordinary journey. When Ken first asked Stella to work with him at his Gemini workshop in Los Angeles, the artist thought printmaking beneath contempt. There is a marvellous photo in which the printer slaves over an image, while Stella sits some distance away, eyeing him suspiciously. Indeed, Stella says it even crossed his mind that there had been yet another Martian invader, as described by H.G. Wells.[11]

Even when the artist relented and began to make prints, they were usually lithographs based on his paintings. As luck would have it, Stella noticed a sheet of plywood on which the remnants of routed shapes remained, creating powerful linear networks. Lo and behold! He had invented the readymade woodcut. As the process seemed very natural, very unforced, Stella became increasingly aware that he might develop a relationship between painting and printing. Equally, he realised there could be links between sculpture and printing.

Hey presto! His attitude was transformed.

Among Tyler's dicta is the belief that

> a strong beautiful black and white print is sometimes more difficult to make than a fifty-colour print. You can disguise a lot of mistakes with colour. Frank Stella has made some of the greatest black and white etchings of all time. If Dürer was here, he would walk over and tip his hat.

Certainly Stella's *Swan Engravings* were greeted with paeans of praise from discerning critics. Robert Hughes noted that the artist's work had twice 'caused shifts in the art wind' – once with black pinstripes, raw canvas between them – then by the 'slangy outrageousness' of his later work. Hughes credits this to Tyler's 'experimental verve and doggedness', suggesting that the collaboration between the two has been 'one of the great partnerships in modern American art'.

When, during the 1980s, Stella first began exploring *Moby Dick*, the sophistications he and Tyler devised extended to prints with domes. In fact, the very first dome, *Jonah Historically Regarded*, forms part of Tyler's gift to the Tate. The images

11 *War of the Worlds* was read on live radio by Orson Welles as if it was breaking news. In fact, he was reading a story written by H.G. Wells.

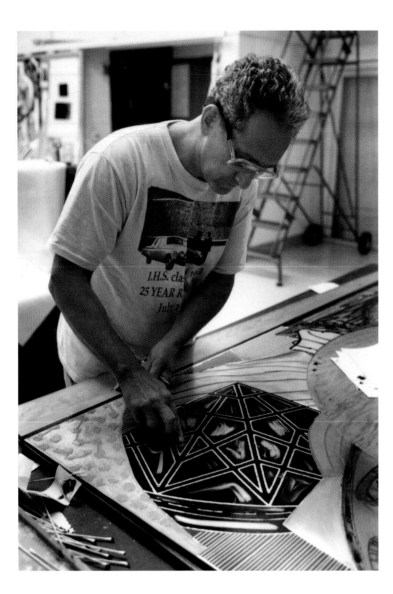

that became domes were first developed as flat prints, inscribed with a central circle. The dome – a separate entity – was added later.

Having a weakness for black and white, I find the *Moby Dick Engravings* particularly beautiful. The print entitled *The Cabin. Ahab and Starbuck* not only has endless subtleties in its monochromatic range, but the abstract patterns – geometric or organic – are extraordinarily varied. They suggest falls of snow, impressions from steel footplates, constellations of stars, uninhibited scribbles, fine netting, threatening clouds . . .

In the midst of this extraordinary endeavour, I received a letter from Ken:

I'll write regarding my schedule for the rest of the year and to give you information on Stella's Dome works. The large hydraulic press that I ordered for Stella's large woodcut, will be completed in March, so I'll be off to Portland to test it. It's all a bit mad, now that the art market is in recession, but it will be exciting to make seven by ten foot prints in one printing!

The prints to which Tyler refers are *Juam*, and its state. *Juam* slightly exceeds two metres in height, and extends to one and a half metres in width. Both these huge prints form part of Tyler's

gift to the Tate. Their specification is daunting. Quite apart from the size, *Juam* rejoices in fifty-nine colours, printed in three different techniques. As if this was not enough, additional colour was applied by hand.

Stella also made three inventive suites entitled *Imaginary Places*. Describing them in an essay, Sidney Guberman pointed out that each print involved at least five of the following ten techniques: lithography, etching, engraving, aquatint, mezzotint, screenprinting, relief, collograph, woodcut and hot foil stamping. Some are printed in fluorescent colours. They have also been given rib-tickling names – such as *Figlefia* and *Fattipuff*.

I always thought Masami Teraoka's prints were meant to be amusing although, by his own account, he found it difficult to adjust to diverse cultures. In his case, it meant reconciling Japanese Ukiyo-e with American Pop art of the 1960s. Indeed, when Iain Gale wrote an article about Teraoka in the *Independent*, he entitled it: 'Not floating, but drowning'.[12] In the *Hawaii Snorkel Series* Teraoka based his images on various episodes in the surf, claiming that the boy pictured in *Longing Samurai,* could well be the punk who later journeyed to America.

The only other gift by an artist whose name begins with 'T' is the handsome abstraction by Jack Tworkov. Then, apart from an ornamental paperwork, devised by Robert Zakanitch, John Walker alone remains. Walker's portfolio tells a moving story, based on his father's experiences during the First World War. Although Walker Senior survived, he was never able to forget the death of comrades who drowned in the liquid mud of the trenches. In a suite entitled *Passing Bells*, Walker depicts his father in uniform, with a head like a sheep's skull – part sacrificial lamb, part survivor.

The subject with which I end is both Ken Tyler's generosity, and his vision. I do not refer only to the gifts he has donated to so many institutions, but to the knowledge he has been willing to share. His central theme is collaboration, and he wants – as his wife Marabeth puts it – 'to pass on the flame to future generations'.

When Ken came to Canberra during my watch, he invariably visited the local workshop, to share 'tips and wrinkles' about prints. He was always positive, stressing things the members of his audience could accomplish, if only they tried. He not only talked to students, but to artists from many different institutions. Nor did he confine himself to Canberra. He would sometimes rush off to Melbourne – some 350 km to the west – and conduct a workshop there.

I once attended a meeting where Ken was enthusing about prints, encouraging artists to experiment. 'You can do monotypes in your own studio,' he said. 'You can certainly make etchings and woodcuts in your studio. You can try screen-printing and, with practice, become quite sophisticated. We have also shown the world, that is is possible to make paper in a very small facility.'

Tyler's wife, Marabeth, says Ken is the last person on earth who would call himself a 'Master Printer': 'He sees himself as a collaborator, working with one artist at a time and giving his all.' He has run many apprenticeship programmes, both in the United States and overseas. In addition to this, he has helped to make four films. In them he appears as 'Action Man'. His aim is, as always, to reveal the joy of printmaking.

The films feature: 1. Tyler's first workshop, Gemini; 2. Rosenquist's *Welcome to the Water Planet*; 3. Roy Lichtenstein's *Reflections* and *Nudes*; and 4. Frank Stella's *Imaginary Places*. 'He hopes these films will open up the field and let new talent in,' says Marabeth. 'But will he retire?' I ask. 'I'm sure he will get his hands inky again,' she says.

12 His article appeared on 15 September 1992.

Everything goes and anything is possible

Kenneth E. Tyler in conversation with Sean Rainbird

You started out on the West Coast, first at the legendary Tamarind Lithography Workshop, later as founder of Gemini GEL. Can you outline how you came to establish your workshops on the East Coast?

After spending ten years in Los Angeles I found myself needing a life change and a new way to use my printing skills. In 1973 I decided to sever my relationship with my two business partners at Gemini GEL [Graphic Editions Limited] and move to the East Coast. Primarily, I moved in order to be close to some of the artists with whom I wanted to work closely in a more experimental way and to further develop a multi-media workshop. Having purchased a house with a large garage in Southampton, Long Island, I was intent on setting up a modest workshop. Unfortunately, I couldn't get planning approval and my divorce from my partners developed into a protracted legal dispute.

With such obstacles, how were you able to move forward?

This litigation proved to be very expensive and I was forced to open a much larger printing operation to pay for it. With the kind guidance of Robert Motherwell, I located it in the hamlet of Bedford, New York, just four miles from his home and studio. In February 1974 I established Tyler Workshop Ltd in my renovated carriage house. I changed the name to Tyler Graphics Ltd in March 1975. My first project was with Josef Albers, creating four screen-printed portfolios from 1974 to 1976. During this time I added direct and offset lithography to print editions with Motherwell, as well as intaglio and relief printing equipment. In addition, I worked at John Koller's paper mill in Woodstock, Connecticut, making paper reliefs for Frank Stella, coloured papers for Ron Davis's intaglio prints and Ellsworth Kelly's coloured paper pulp images. In 1977 I set up my own paper mill in my garage. I continued adding to the carriage-house complex until 1985, when I purchased a building in Mount Kisco, which I then remodelled and expanded into a workshop, office and gallery space. In December of 1986 the building was completed and we relocated our workshop to Mount Kisco in early 1987.

This sounds to me like the key period of establishment and consolidation following your departure from Los Angeles. You appear to have had a clear idea how you wanted the workshop to expand.

One of my goals upon leaving Los Angeles was to establish a multi-media workshop and explore direct and offset lithography, intaglio, relief, screenprinting and paper-making – all under one roof. My immediate plans, as I kept expanding the working space, were to continue collaborations with Albers, Motherwell, Stella, Kelly, Roy Lichtenstein and David Hockney on extended projects, using the new facilities of the workshop.

Did you rethink the traditional structure of the print workshop?

My idea was to work more closely with the artists by collaborating with them on a frequent basis both in their studios and in the workshop. I set about training a new staff of printers who would become skilled in all printmaking media, including paper-making. There would no longer be master lithographers, master etchers, etc., working only in their separate areas of expertise. They would become collaborators as part of a group that could serve the artist in all of the media, and they would work as a dynamic team doing whatever was necessary for the project.

Were there specific projects that showed you the merits of this way of working?

This team concept was perfected over the years working with Stella on his complicated and time-consuming projects. The team approach was more efficient and made it possible to spend longer periods working on projects in greater depth and scale. I continued the research and development that I'd begun in Los Angeles, exploring various processes and techniques, both inside and outside the workshop, in order to assist the artists in developing their ideas and to increase the capabilities of the workshop.

Some of the artists in the Tate gift, such as Steven Sorman, Terence la Noue,
John Newman and Ed Baynard, are less familiar to European museum visitors. Can you
explain how those collaborations came about and what sustained them for so long?

With the exception of Steven Sorman, who was an accomplished printmaker, the younger artists I invited to collaborate with me were not terribly familiar with the various print mediums or with papermaking. I selected new artists on the merits of their art and according to what medium I thought their imagery would work best in. We often made preliminary trials to demonstrate the possibilities of the suggested medium before we began scheduling projects. Even when artists worked with the same techniques defined by other artist projects, they always altered things and generally made a new contribution. There was, I suppose, a degree of competitiveness between the artists working at the shop. However, this never became a hindrance. Instead, it seemed to give projects greater momentum and vitality. In retrospect, many of the works created by Sorman, La Noue and Newman added to our printing and three-dimensional multiple skills. They favoured process, and experimented with techniques and materials in highly creative ways that often influenced the working procedure of other artists in the workshop. Their art, in my mind, contributed greatly to the overall body of work produced at Tyler Graphics Limited.

Presumably, these artistically adventurous collaborations represented a commercial risk, since the work of younger artists was less well positioned in the art market.

> The revenue from the sale of the more famous artists' works funded the efforts of the younger artists to a great extent, until we were able to develop their print market. In a few circumstances we were unsuccessful in developing a market for the work we produced. Sadly, I attribute this to a lack of artist recognition in the market place among collectors, dealers and institutions. This problem persists in the multiples business and intensifies as critics and curators favour celebrity artists and blockbuster exhibitions. For this reason, I like to show how various artists influence, benefit and learn from each other through their work, in the workshop setting of collaboration, research and development, through artistic rivalry and experimentation.

The nature of your contact with the artists you worked with also appears to have changed when working in the countryside outside New York. What were the critical elements of this?

> In Los Angeles all out-of-town artists were housed in hotels during their brief stays at the workshop. The situation in Bedford and Mount Kisco was different, since both shops had special apartments connected to the workshop, where artists could stay and have access to the workshop's artist studio at any hour. For the most part, the New York artists commuted daily to the workshop and I often went to their studios. Artists who lived far from New York, such as Joan Mitchell, Hockney and Masami Teraoka, set up residence, so to speak, in the TGL artist's studio, sometimes living there and working in the shop for months. Because I spent more time with the artists on individual projects on the East Coast than I did on the West Coast, I was able to investigate more complicated and hybrid forms of print- and paper-making with them. Also, my frequent visits to their studios kept me more informed of their artistic development and alerted me to any new graphic possibilities. Generally speaking, the West Coast was a perfect place for me to begin my career and the East Coast was the better place for me to develop.

How did the greater amount of time you spent with artists at the workshop and in their studios guide your decisions about the equipment you introduced or the facilities you developed?

> I certainly gained a keener sense for cutting-edge technology on the East Coast. Because I was in complete control of the business, I could invest in whatever area I decided was important. It was a challenge to work on projects that had never before been attempted in print- or paper-making. An even bigger challenge was making a profit from the experience, which wasn't always possible. Without the synergy of gifted artists and my skillful, intelligent staff, I could not have accomplished what was done. Every workshop has a unique environment that influences

how people identify and work in it. The quality of projects being worked on also affects the way in which people react to their job.

Any examples in particular?

I believe that the artists and printers were influenced by the highly experimental multi-media works of Stella, just as they were by Hockney's *Paper Pools* project, to name just two.

So while the success of this collaboration emboldened you to take commercial risks in support of these technical experiments, did this creative partnership extend into many other areas of Stella's artistic output?

From the phenomenal group of prints by Frank Stella in your gift, it's clear that you enjoyed a particularly close, indeed unique, working relationship, having begun working with him on the East Coast in 1975 on the paper-relief project. How would you characterise this collaboration?

Stella and I first worked together in Los Angeles in 1967 and this represents one of the longest print collaborations in contemporary times. Our projects were like building blocks; we built upon each using the technology from the previous one to advance the new. Other artists benefited immeasurably from this activity, which was constantly in progress in the workshop. It was widely accepted that Stella's work was very innovative for its time, and artists studied his work and often adopted the techniques and materials he used. Stella made the workshop an extension of his own studio and was a frequent visitor – as my staff and I were to his studio. My willingness to invest in his ideas made it possible for the workshop to acquire larger and more complicated presses and equipment. The large hydraulic platen press (1991); the large combo etching/lithography press (1989); the water-vacuum paper-forming equipment (1988), and the vacuum-forming machine (1994) were all pieces of equipment made especially for Stella projects and were, of course, employed for other artists' work.

So while the success of this collaboration emboldened you to take commercial risks in support of these technical experiments, did this creative partnership extend into many other areas of Stella's artistic output?

Beginning in 1973, I worked for Stella as a technician, setting up model-making facilities for his studio work outside of the print workshop, assisting him in establishing contacts for new materials, and manufacturing parts for his art. I supervised his Bridgeport workshop at Swan Engraving, which made his honeycomb relief sculptures from aluminium and magnesium. We developed our magnesium-plate technology for intaglio printing by experimenting with the cast-off shards from the reliefs. These shards were the primary elements used in the collage plates for the *Swan Engraving* series. Later, during the laser cutting of the *Circuit* relief shapes, Frank and I discovered that the backing boards on the machine contained a history of the relief shapes routed into the boards. We took these boards back to the workshop, inked and printed them and used them as the key blocks for his *Circuit* series of relief prints. In the 1990s we used pieces of his open sand castings

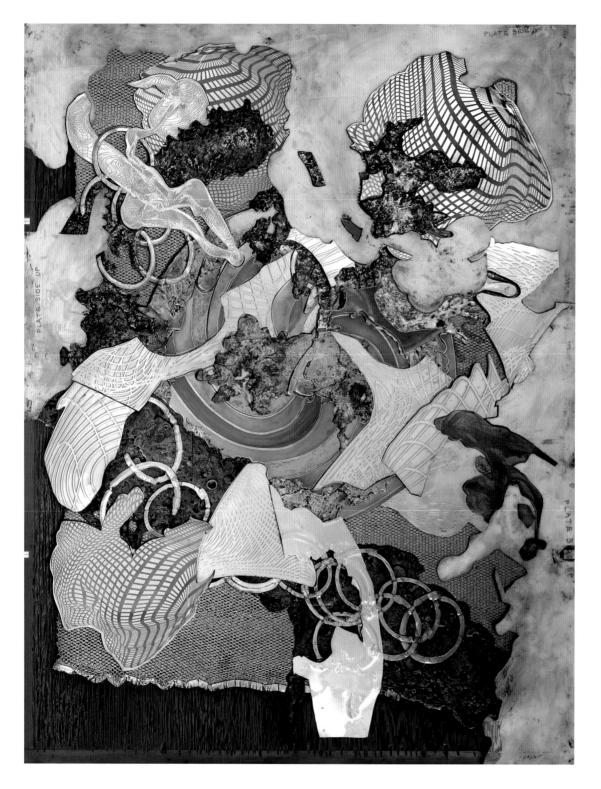

The plate for Frank Stella's *Juam* showing its composite construction of different materials collaged onto the base support.

Juam 1997
Relief, etching, aquatint,
lithograph, screenprint,
woodcut and engraving
on paper
2375 × 1545 mm
P12327

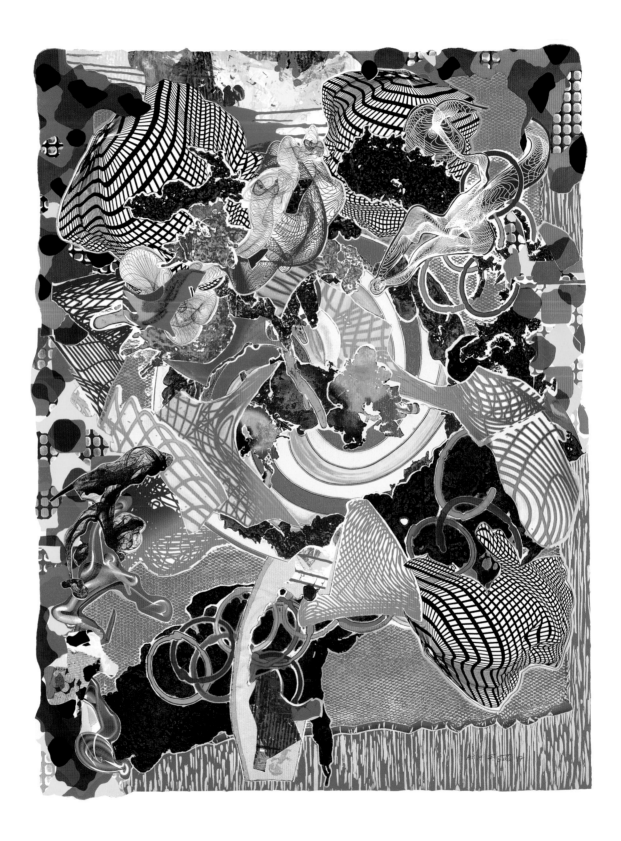

of bronze, aluminium and stainless steel from the foundry (where he was making his large metal sculptures) as printing elements. We ventured on collaborations outside the workshop, working on four one-of-a-kind tapestries. These involved intensive collaborations with Aubusson-Felletin Tapestry Works (Atelier Pinton) in France, resulting in three different tapestries, created in 1996 and 1998. The fourth tapestry was created in Australia in 1996 by The Victorian Tapestry Workshop. Additional fibre-related collaborations produced a series of oversize silk shawls and scarves. Finally in 2001, in collaboration with Emerging Markets Resource Development, White Plains, New York, and David Mirvish Designs, Toronto, Canada, we created the *Vortex Engraving* series of ceramic plates.

That sounds like an unusually rich and extensive creative partnership, which showed a capacity to grow into quite unexpected areas.

We've enjoyed a wonderful symbiotic relationship over the years, and I believe we pushed printmaking further than any other collaborators had. Our relationship was unique in yet another way. In the early 1990s we started to print his images and compile an inventory of proofs for his collage activity. Stella used this inventory of printed colour images, both in his New York studio and our workshop, for making his collage studies for prints, and for enlarging to use as studies for his paintings. Or he used them just for making large collages. Most of this printed material was colour lithography, with a sizeable number in intaglio and screenprinting. Stella often cut up the images and the sections he had – enlarged to fit whatever project he was working on. The enlargements were then made into photo plates and printed either in lithography, intaglio or screenprinting. They were then often re-introduced back into his inventory. I also employed the services of the master engraver at Tumba Bruk in Sweden to engrave Stella's photo smoke-ring images, which we enlarged and printed in various mediums for his use in paintings and prints.

Were you able to collaborate with other artists over similar lengths of time and in similarly fruitful ways?

Another example I can give of the importance of working continuously with an artist over a long span was my twenty-five year relationship with Helen Frankenthaler. The two of us challenged each other's creativity with our diverse collaborations, ranging from a folding bronze screen project at Tallix Foundry (in Beacon, NY), to sprayed paper pulp and explorations into every graphic medium. Our relationship seemed difficult and combative at times. Nevertheless, it developed into a trusting, friendly and above all artistically rewarding one. A project to illustrate this was the long collaboration on *This is Not a Book*, from August 1995 to January 1998. It was a multi-media, multi-page, image-and-text, bound compilation involving nine collaborators working in handmade paper, intaglio, lithography and pochoir, not to mention bookbinding. Frankenthaler created twenty-six images during this

collaboration, using nine for the book. Ten images were abandoned, with Helen further developing seven others to become the *Magellan* portfolio. The *Magellan* series, using etching, aquatint and drypoint, was the last work printed and published by the workshop in 2001 before the shop was moved to Singapore.

Did the innovations you developed with Frankenthaler and Stella benefit any of the other artists you worked with on a less regular basis?

My involvement with the making of Stella's original reliefs led to the workshop making sculptural papers, which in turn Stella used in producing models in his studio. The printed paper reliefs made after his 1975 *Paper Relief* project were based on these studio models. This paper modelling influenced Anthony Caro in collaborating with the workshop on his one-of-a-kind paper sculpture projects in 1982 and 1993. In 1976 I also invented an archival paper honeycomb structural panel, patented under the name Tycore, for use in making Stella's paper relief models. It's interesting to see how differently artists used a particular new process or technique. Sorman used Tycore for his 1988 screen project titled *From Away*. The revised ukiyo-e woodcut technique that we invented for Frankenthaler's 1998 *Genji* series was also used by Donald Sultan for his 1999 woodcut flower project and for three large four-panel woodcuts in 2000, *Green Apples and Eggs Jan 12, 2000*, *Apples and Eggs Jan 11, 2000* and *Black Eggs and Roses May 22, 2000*. Frankenthaler pushed the medium further with her three-panel print *Madame Butterfly* 2000, and I'm sure Sultan could have further excelled with the technique had he made additional works.

You seem to have moved away from more traditional definitions of printmaking, both from the idea of making multiple versions of a single image, and from working exclusively in two dimensions. Why did this happen?

Because I believed in blurring the lines between the various disciplines in the workshop – i.e. lithography, intaglio, relief, screenprinting, collage, photo-mechanical means, paper -making and three-dimensional multiples. I set about creating a climate of limitless possibilities, where everything goes and anything was conceivably possible. Learning how to apply more ink to the printed surface or more colour to paper pulp, or how to combine mediums to get a richer range of colour, texture and relief effects was all part of the workshop's daily exercise in increasing the parameters.

Did it influence the artists with whom you worked to test the boundaries of what might be possible in printmaking?

For artists like James Rosenquist, my 'can do' attitude convinced him to tackle scale and techniques in paper- making and print that he'd never thought of doing before. This became possible only after many years, when I opened my new larger

workshop and paper mill in Mount Kisco in 1987, which impressed him with its scale and complexity. His large mural-size colour paper pulp works with lithography collage and relief printing titled *Welcome to the Water Planet*, *House of Fire* and *Time Dust*, created a new paradigm. Only in a state-of-the-art facility with talented collaborators could this level of achievement occur.

How had your own role evolved to fulfil these broader ambitions?

I've often noted that my role was that of Director/Technician, supervising the various workshop activities and resolving questions of technique and process to assist the artist in the making of their art. I liken it to what takes place in the theatre with opera or complicated musicals. Certainly, my early experiences with stage design and my collaboration with a variety of manufacturing facilities such as steel mills etc. prepared me for pushing the technological envelope in print- and paper-making. The environment in my East Coast workshops in Bedford and Mount Kisco was unique – part traditional and part experimental, both print shop and paper mill. Often the workshop became the personal studio for the artist, with my staff and me working on projects unrelated to our printing/ publishing programme. For some of the artists I served as a clearing house for researching their ideas, using commercial manufacturing applications or products. Often this activity led to a new print project using a novel approach or material. Intentionally, the work I did personally for the artists and the print activity performed by the workshop was not clearly separated. I tried to serve the artist in a broader and more creative manner than just as printer and publisher.

Over the past four decades you've dramatically stretched our ideas about the possibilities of printmaking. How far have you transformed expectations in the wider world and what has been the response from museums and the art market?

There's been a decline in the number of collectors dedicated to forming major contemporary print collections destined to wind up in museums. Print departments in museums never have sufficient funds to keep up with contemporary print purchases. Once printed works became part of private and commercial collections, along with paintings and drawings, they were in competition for investment and also for the available display space. As more editions were made, more impressions were available to sell in the art market and what seemed like an endless source of collectors soon became a glutted market. Too many multiples and too few collectors became a reality. One-of-a-kind paintings and drawings require a smaller collecting audience and for this reason they're often considered rarer and safer as investments. Print exhibitions in museums have become less attractive to directors and curators. When there's an exhibition of prints, there's often very little media attention, which influences attendance.

How do you think this could or should be remedied?

To cure this problem we need to have more museum exhibitions, with greater media coverage to focus attention on the work. More critical writing in high-profile media is crucial to attracting collectors and kindling interest. Also, professional criticism is necessary to praise the good works and criticise the bad, regardless of the fame of the artist. Showing the print work of only the superstars of the moment does little to advance the more general appreciation of prints in our society. This is the one area where institutions can play a major role in correcting the public's perception of what's noteworthy art and what's not. As a natural corollary, when collectors are more informed and educated about prints, they seek out dealers to buy from. Dealers then start stocking their inventories.

Since the opening of Tate Modern in 2000 we've attempted to display prints in several ways, either alongside works in other media, or in dedicated rooms. Although one might argue that each medium benefits from different kinds of attention and looking, the former approach gives prints a different profile from that achieved when they're shown only in the company of other prints.

'Print only' exhibitions are necessary. However, exhibitions showing prints along with paintings, sculpture and drawings are far more compelling! Artists such as Picasso and Stella used printmaking and painting equally, with breakthroughs in one medium opening up discovery in others. It's no more appropriate to think of printmaking as the lesser medium in the plastic arts than it would be to denigrate the *a cappella* voice in music compared with instrumental composition. There's cross-pollination in all artistic media and when one sees, for example, how an artist's graphic work has revolutionised his painted or sculptural compositions, or vice versa, our understanding and appreciation only deepens. Needless to say, only prints of outstanding quality can rise to masterpiece status. However, museums need to show the quality works of lesser known artists with the works of established artists.

Following on from these questions about showing prints either on their own or in a wider context, are there particular ways of displaying prints that you'd like to see adopted or tried out?

It would be good to see beautifully designed, colourful spaces for the display of prints in exhibitions, instead of the side-by-side-in-a-straight-line structure, hanging on overly illuminated bone-white walls. Well-written wall labels and working photographs that give the audience an understanding of what they're looking at would go a long way towards exciting and educating the public. Generally speaking, the public is interested in process and how things are made. More can be done to capitalise on this!

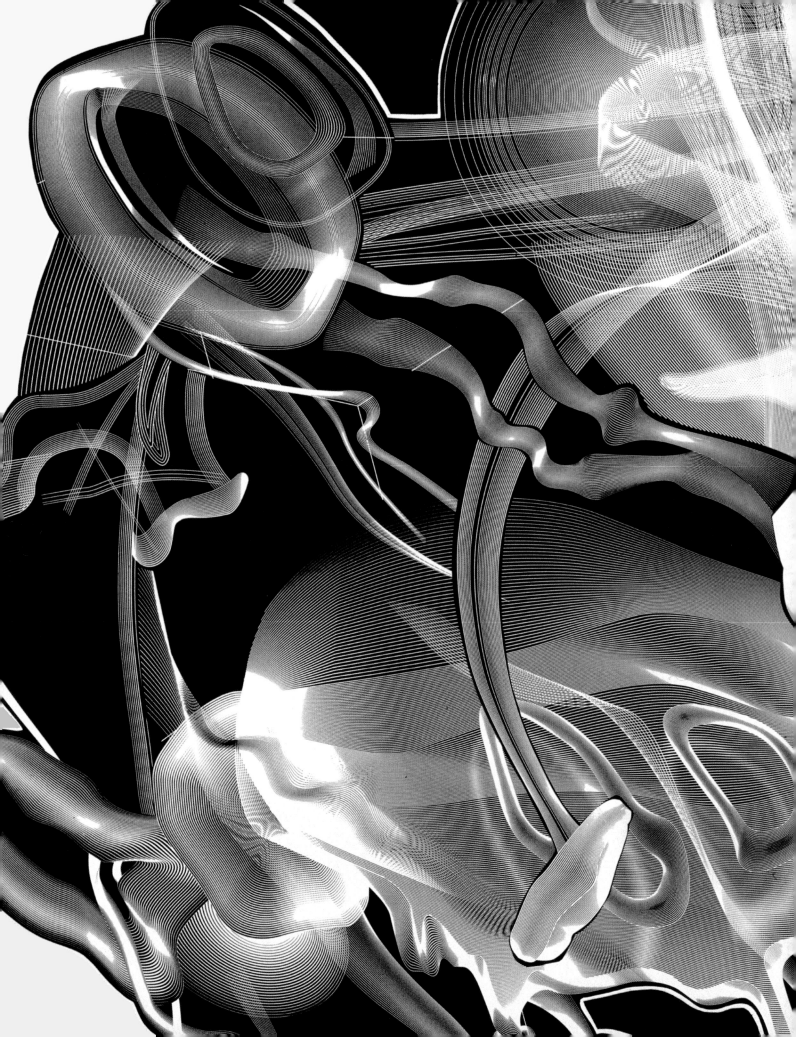

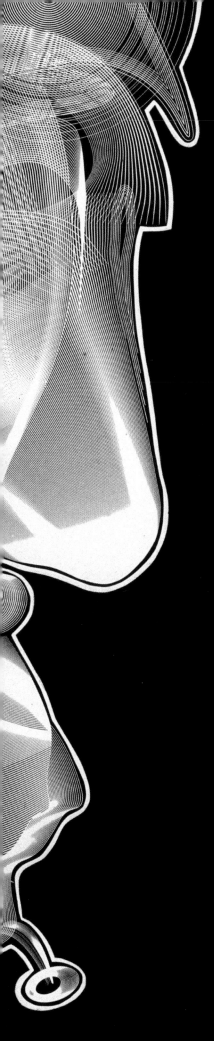

The Kenneth E. Tyler Gift

Authorship of catalogue entries is
indicated as follows:

HD = Helen Delaney
KR = Kathryn Rattee

Biographies by Rachel Taylor

Dimensions are given in millimetres, height before width,
and refer to the size of the image.

1 Monotype (B-2)

1981
monotype on paper
865 × 590 mm
P11997

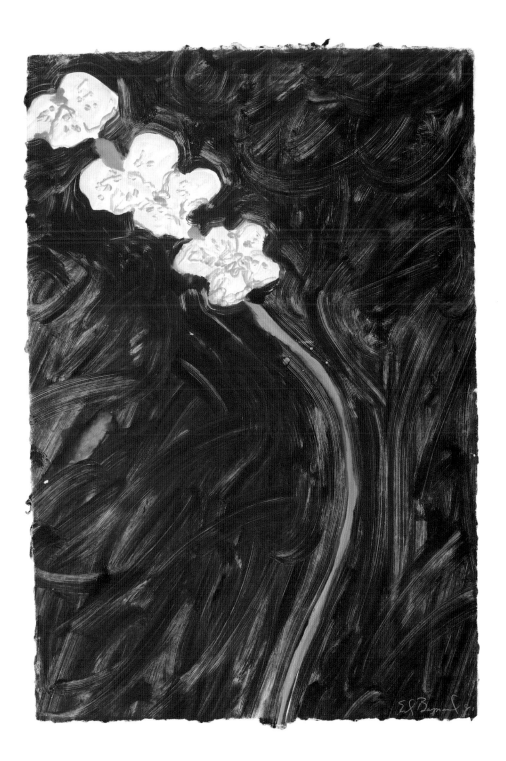

Ed Baynard (b.1940)

Baynard was born in Washington, D.C.
and currently lives and works in New York.
He has exhibited in numerous solo shows
including the Austerer Crider Gallery, Palm
Springs (2002), the Eleanor Austerer Gallery,
San Francisco (2001), the Wright Gallery,
New York City (1999) and Gallery One,
Toronto (1999). He has also participated in
major group exhibitions including *American
Still Life 1915–1995* at the Metropolitan
Museum of Art (1997), *American Drawing
1963–1973* at the Whitney Museum of
American Art (1973) and *Landscape* at the
Museum of Modern Art, New York (1972).
His work is included in the permanent
collections of major American museums
including the Metropolitan Museum, the
Whitney Museum, the Museum of Modern
Art and the Walker Art Center, Minneapolis.

2 Head VII

HEADS FROM BALANCE, P11998–P12012 (incomplete)

1998
drypoint and aquatint on paper
227 × 283 mm
P12004

3 Drift

1996
linocut and lithograph on paper
695 × 1020 mm
P12031

Per Inge Bjørlo worked with staff at Tyler Graphics on the prints that make up the *Heads from Balance* series between March 1996 and October 1998. The series comprises seventeen intaglio prints that depict a human head from a variety of perspectives. All the works were printed on paper handmade at the Mount Kisco studio, and incorporate etching, drypoint and aquatint. The heads in each individual image are predominantly rendered using etched and drypoint lines, whereas aquatint has been employed to create the dark tonal washes that appear in many of the prints.

The series has a strong autobiographical significance for Bjørlo, who ran away from his home in Norway at the age of sixteen to go to New York. He has described the experience of travelling to America as a process of searching and 'looking for new rooms in [his] head'.[1] Many of the figures in these images have upturned faces, suggesting this notion of searching. It is a theme that runs through much of Bjørlo's work. Specifically, it relates to his desire to reach what

he has described as a 'balance' or greater understanding in his life and thoughts, something that he has only been able to reach through his art practice.

Bjørlo has said that his collaboration with Ken Tyler helped him work out the imagery that appears in the prints in this series and in a group of related paintings. Their focus on an isolated individual figure underlines their introspective quality. The sharp lines and the stark, mask-like faces depicted give the works a bleak feeling, which Bjørlo has related to a difficult period earlier in his life. He explains:

> These images are from the layers of experiences and thoughts stored in my head as pictures. My difficult childhood – the pressure from social relationships, my parents, other adults. The painful sorting and searching for some images to believe in. My early years of trying to find a balance.[2]

KR

1 Per Inge Bjørlo, *Heads from Balance*, Mount Kisco, New York 1998, np.
2 Ibid.

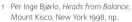
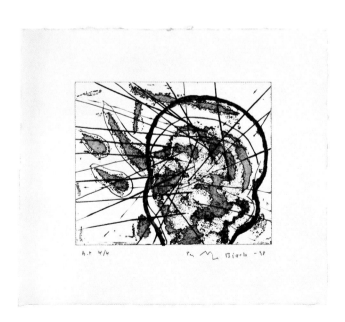

Per Inge Bjørlø (b.1952)

Bjørlo is predominantly known as a sculptor who works with reclaimed industrial materials. He was born in Ålesund, Norway and currently lives and works in Hønefoss, Norway. He studied at the Kunsthøgskulen, Bergen, Norway between 1974 and 1978, at Poul Christensen, Helsingør, Denmark in 1976 and the Kunstakademi, Oslo, Norway between 1977 and 1982. His recent solo exhibitions have included The Artists Society, Oslo (2001), the Hara Museum of Contemporary Art, Tokyo (1998) and the Lillehammer Kunstmuseum (1997). He also exhibited at the XVIII São Paulo Bienal (1985) and the XLII Venice Biennale (1988). His work is included in the permanent collections of major museums including the National Museum of Contemporary Art, Oslo, the Louisiana Museum of Modern Art, Humlebæk, and the Walker Art Center, Minneapolis.

12/27

4 Jackass Free

CARNIVAL OF ANIMALS
P12032–P12042 (incomplete)

1979
etching, engraving and drypoint on paper
553 × 590 mm
P12034

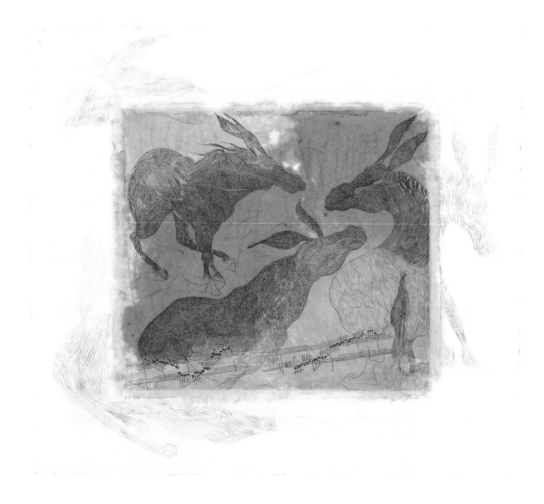

Stanley Boxer (1926 –2000)

Boxer was born in New York City, where he lived and worked until his death in Pittsfield, Massachusetts. He studied at the Art Students League after serving in the US Navy during the Second World War. His painting was championed by critic Clement Greenberg. The Rose Art Museum at Brandeis University staged a career retrospective of his work in 1992. His last solo exhibition before his death took place at Salander-O'Reilly Gallery, New York in 1999. His work is in the collections of major museums including the Whitney Museum of American Art, the Museum of Modern Art, New York, the Museum of Fine Arts, Boston and the Hirshhorn Museum, Washington, D.C.

5 Dusty

1993
paper and paint
280 × 355 × 350 mm
T11798

Anthony Caro (b.1924)

Caro is known predominantly as a sculptor.
He was born in New Malden, Surrey in 1924
and studied at the Royal Academy Schools,
London between 1947 and 1952. He acted
as an assistant to Henry Moore between
1951 and 1953. Caro taught at St Martin's
School of Art, London between 1953 and
1981 and his abstract welded sculpture
was hugely influential on the subsequent
generation of artists. He has staged major
retrospective exhibitions at the Museum
of Modern Art, New York in 1975 and at
the Museum of Contemporary Art, Tokyo
in 1995. More recently he participated in
the 1999 Venice Biennale. His numerous
prizes include the Praemium Imperiale for
Sculpture in Tokyo in 1992 and the Lifetime
Achievement Award for Sculpture in 1997.
He was knighted in 1987 and received the
Order of Merit in 2000.

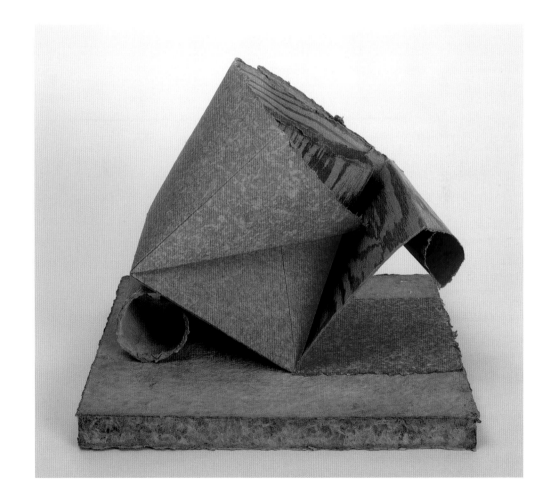

6 Trestle Trains

1978
lithograph on paper
940 × 1353 mm
P12063

William Crutchfield (b.1932)

Crutchfield was born in Indianapolis.
He studied at the Herron School of Art,
Indianapolis; Tulane University, New
Orleans and the State Art Academy,
Hamburg. He currently lives and works
in San Pedro, California. He has had solo
exhibitions at the Norton Gallery and
School of Art, West Palm Beach, Florida
(1978) and the ARCO Center for Visual
Arts, Los Angeles (1979). He has also
participated in group shows at the Museum
of Modern Art, New York, (1971) and the
National Gallery of Art, Washington, D.C.
(1984). In 1982 he was named Distinguished
Artist of Los Angeles.

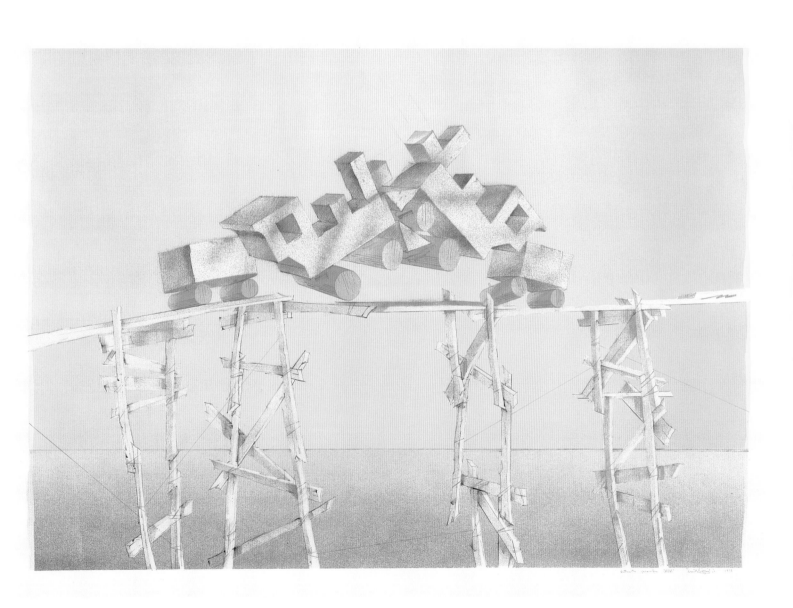

7 Tetra

1976
lithograph on paper
1152 × 843 mm
P12068

Mark di Suvero (b.1933)

Di Suvero is an American artist predomi-
nantly known as a sculptor. He was born
in Shanghai. He moved to California in 1941
and attended San Francisco City College
in 1953 and the University of California
at Santa Barbara from 1954 to 1955. He
currently divides his time between New
York, Petaluma, California and Chalon-
sur-Saone, France. His recent exhibitions
include the John Berggruen Gallery, San
Francisco (2003), the Paula Cooper Gallery,
New York (2003) and the Gagosian Gallery,
New York (2001). His work is represented
in the permanent collections of major
museums including the Art Institute
of Chicago, the Whitney Museum of
American Art and the Wadsworth
Atheneum, Hartford, Connecticut.

8 Mirabelle

1990
lithograph on paper
764 × 942 mm
P12069

When Helen Frankenthaler made her first prints with Tyler Graphics Ltd (TGL) in 1977 she was already an accomplished printmaker. She had made over fifty prints, including lithographs, intaglios, woodcuts, silkscreens and pochoirs. In 1961 she made *First Stone* at Universal Limited Art Editions (ULAE), a lithograph and her first published print. Sixteen years later, her first prints with Ken Tyler were also colour lithographs. The combination of their multiple stones and aluminium plates perfectly achieved the floating forms that she sought. The 1995 suite of lithographs, *Reflections*, continues her enduring passion for this medium. Tyler has commented that 'for Frankenthaler, there is nothing like drawing on the receptive surface of prepared limestone. Lithography stones are responsive to every gesture. It is possible to create combinations of ethereal washes, crayon lines, and dense brushstrokes. Tones may vary from very delicate washes to fully saturated solids'.[1] For an artist for whom nuances in colour and subtle shifts in texture have always been crucial, lithography provided the perfect printmaking technique.

Despite her extensive printmaking experience, Tyler was able to provide Frankenthaler with radical technical departures within each medium, so that she was exposed to entirely new methods and new materials. He was also particularly responsive to what has been described as her 'dialectical' working method. Frankenthaler would produce an image, and then begin the lengthy process of adding and subtracting printed elements, and making endless changes, experimenting all the while with different orientation, colour and paper. Pat Gilmour has commented on her perseverance and exacting standards: 'Frankenthaler expects the printer to be willing to try out a shape in fifty different places, on twenty different papers and with as many different mauves as may be necessary to get the image exactly right. Unless the workshop does this and eventually satisfies her, the print is scratched and she will not sign it.'[2]

This 'dialectical' approach also informed the *Reflections* series, which was started in August 1993 and completed in March 1995. Tyler recalls that, in the summer of 1993, Frankenthaler asked him to bring a selection of small lithographic stones to her studio in Connecticut, so that she could draw on them over the summer months. In August of that year, Tyler visited her seaside studio to collect the first five stones. He writes: 'the images were liquid pools of tusche accentuated with crayon marks that completely covered the surface and overlapped the irregular edges of the stones. Each stone was more lush than the next.'[3] However, the stones presented a printmaking challenge since delicate tusche wash drawings are extremely vulnerable to chemical processes, and so Tyler proposed that they wait until all sixteen stones were proofed in black ink before embarking on the lengthy process of colour proofing.

By September, Frankenthaler had finished all of the stones and Tyler spent the subsequent months processing them and proofing them in black ink. The artist then examined the results and decided to re-work several of the stones. Tyler and Frankenthaler selected a range of papers for the first trial proofings in colour: cream, grey and tan Rives BFK and white mould-made papers, later adding a pale grey handmade TGL paper. The unique jagged shape of each stone was printed as a flat solid of transparent white or pastel colour, and the wash stones were then printed on top in pale stain-like colours. In February 1994 Frankenthaler drew three larger stones and by the end of the following month she decided that eleven of the sixteen stones needed to be redrawn. She then completely re-worked each using a combination of liquid tusche and crayon. During the following eleven months, she also drew numerous mylars, which were used for the additional colour passages that she added to the

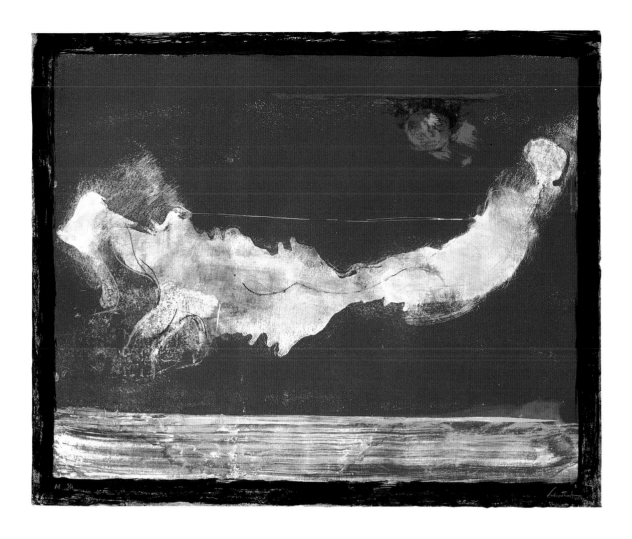

prints over time. The whole process involved the abandonment of six stones and the creation of two new prints from drawn mylars.

This two-year period of printmaking activity resulted in a suite of lithographs that are remarkable for their ambiguous, liquid expression. Pools of brilliant colour dissolve into delicate washes. The series confirms the essential place of colour throughout Frankenthaler's oeuvre. The entire surface of each lithograph is filled: within the edges of the lithographic stone, which are often clearly delineated, amorphous washes contrast with the more linear elements achieved with crayons. The distinction between figure and ground shifts between clarity and ambiguity. Despite their lengthy gestation, they convey the spontaneity and gestural qualities that are associated with Frankenthaler's painting: large abstract canvases with thin washes of pigment, reminiscent of watercolours. Since the prevailing quality of lithography is softness, it is a medium that is exquisitely suited to her sensibilities. HD

1 Quoted in *Helen Frankenthaler: Reflections*, New York, 1995, n.p.
2 Pat Gilmour, *Ken Tyler Master Printer and the American Print Renaissance*, Australian National Gallery, Canberra, 1986, p.109.
3 *Helen Frankenthaler: Reflections*, New York 1995, n.p.

Helen Frankenthaler (b.1928)

Frankenthaler was born in New York City, where she continues to live and work. She attended Bennington College, Vermont between 1946 and 1949 and subsequently studied privately with Hans Hofmann. She became associated with the Abstract Expressionists in the early 1950s and critic Clement Greenberg championed her style of painting as 'post-painterly abstraction'. She has exhibited in numerous solo shows, including major retrospectives at the Whitney Museum of American Art in 1969, the Metropolitan Museum of Art in 1973, the Museum of Modern Art in 1989 and the Corcoran Gallery of Art, Washington, D.C. in 1999. She is an elected member of the National Institute of Arts and Letters.

HELEN FRANKENTHALER

9 All About Blue

1994
lithograph and woodcut on paper
1232 × 734 mm
P12091

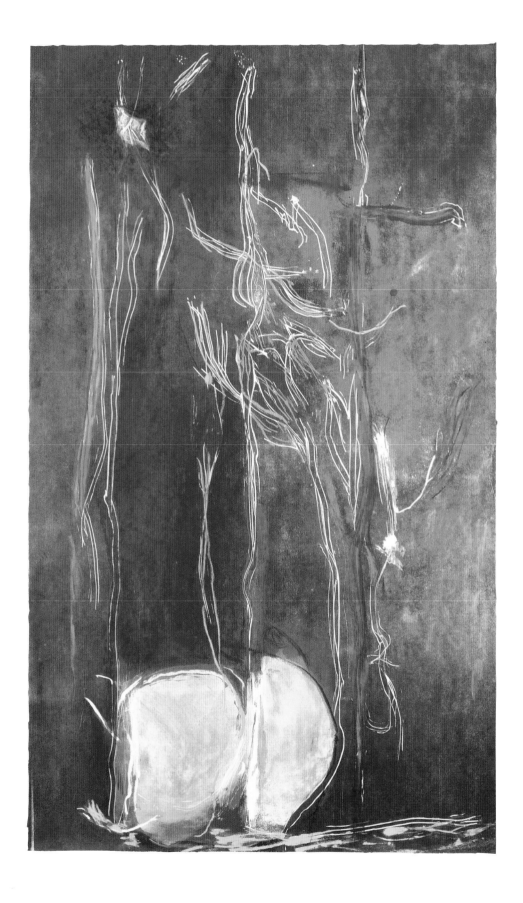

HELEN FRANKENTHALER

10 Madame de
Pompadour

1990
lithograph on paper
1106 × 750 mm
P12092

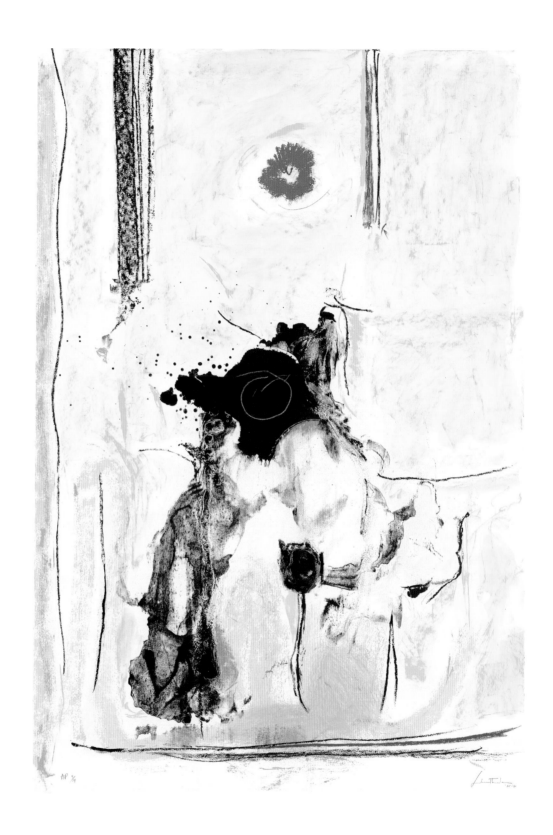

11 Making Music

2000
etching, aquatint and mezzotint on paper
408 × 633 mm
P12078

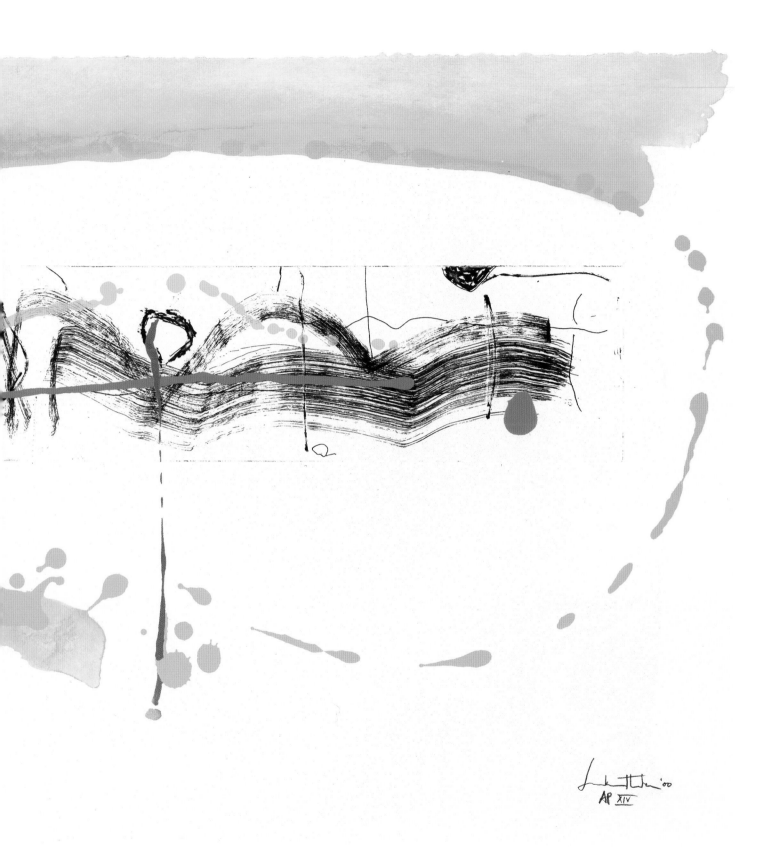

12 Flower-Piece B

1976
lithograph on paper
465 × 291 mm
P12106

13 Flower-Piece B, Crayon Study

1976
lithograph on paper
465 × 318 mm
P12107

14 Flower-Piece B, Cyan Separation

1976
lithograph on paper
432 × 314 mm
P12105

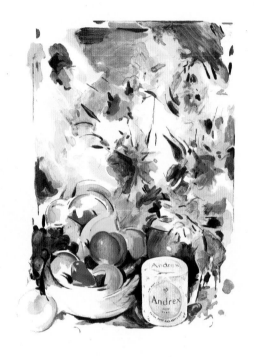

Flower-piece B Richard Hamilton AP96

Richard Hamilton (b.1922)

Hamilton was born in London. He studied
at the Westminster Technical College in
1936, at the Royal Academy Schools from
1938 to 1940 and 1945 to 1946, and at the
Slade School of Fine Art between 1948
and 1951. He was a founder member of
the Independent Group of artists and
writers associated with the Institute
of Contemporary Arts in the 1950s, and
a major figure in the British Pop art
movement. His solo exhibitions have
included major retrospectives at the
Tate Gallery in 1970 and 1992 and at the
Solomon R. Guggenheim Museum, New
York in 1974. He represented Britain at
the 1993 Venice Biennale.

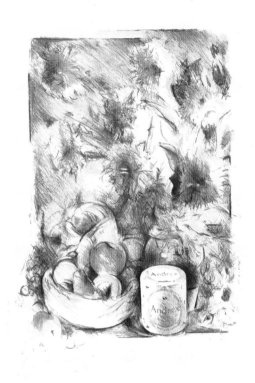

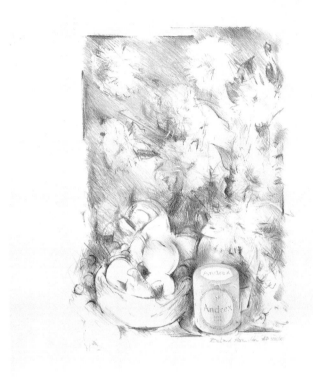

flower piece B — crayon study R. Hamilton 1980

15 Levitated Mass

1983
lithograph, screenprint and etching on paper
791 × 1142 mm
P12108

Michael Heizer (b.1944)

Heizer was born in Berkeley, California.
He studied at the San Francisco Art Institute
between 1963 and 1964 and subsequently
moved to New York. In the 1960s and
1970s he was an influential figure in the
development of Land Art. In 1970 he
exhibited in the International Pavilion at
the Venice Biennale. Major exhibitions of
his work have been staged at the Museum
Folkwang, Essen (1979) and the Museum
of Contemporary Art, Los Angeles (1984).
His work is included in the permanent
collections of institutions including the
Dia Foundation, New York, the Vancouver
Art Gallery, and the Museum Abteiberg,
Mönchengladbach. He currently lives and
works in Nevada.

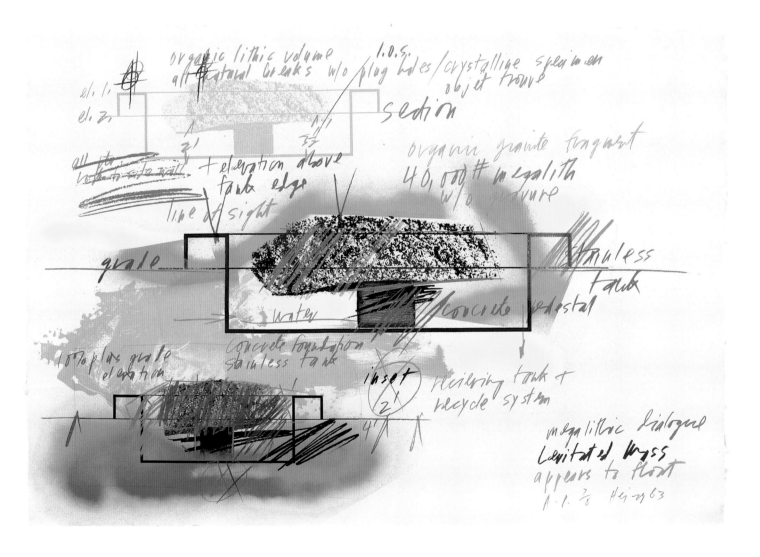

organic lithic volume
all natural breaks w/o plug holes / crystalline specimen
objet trouve
l.o.s.

section

el. 1,
el. 2,

all the
site wall
+ elevation above
tank edge
line of sight

organic granite fragment
40,000# megalith
w/o gravure

grade

stainless
tank

water
concrete pedestal

10%plus grade
elevation

concrete foundation
stainless tank

inset
2"

recieving tank +
recycle system

4'

megalithic dialogue
Levitated Mass
appears to float
H ... 63

16 Prime Moments I

1999
screenprint and paint on paper
232 × 866 mm
P12111

Al Held (b.1928)

Al Held was born in Brooklyn, New York. After serving in the Navy he studied at the Art Students League and the Academie de la Grande Chaumiere, Paris. He has taught at the Yale School of Art since 1962. He has participated in major international group shows including *Abstractions Americaines 1940–1960* at the Musée Fabre Montpellier in 1999, *Abstract Expressionism in the United States* at the Centro Cultural Arte Contemporaneo, Mexico City in 1997 and *Thinking Print: Books to Billboards 1980–1995* at the Museum of Modern Art, New York, in 1996. He has been elected to the American Institute of Arts and Letters.

17 Prime Moments II

1999
screenprint and paint on paper
529 × 783 mm
P12112

DAVID HOCKNEY

18 Pool II-D

2000
lithograph on paper
544 × 739 mm
P12116

David Hockney (b.1937)

Hockney was born in Bradford. He studied
at Bradford School of Art between 1953
and 1957 and at the Royal College of Art
from 1959 to 1962. He established himself
as a major figure in the British Pop art
movement before moving to California in
1963. He currently lives and works in Los
Angeles and Malibu. Major retrospectives
of his work in various media have taken
place at the Los Angeles County Museum
of Art (1988), the Royal Academy of Arts,
London (1995) and the Museum Ludwig,
Cologne (1998).

19 Saint Martin Landscape

1979
lithograph, screenprint and collage on paper
388 × 557 mm
P12117

Ellsworth Kelly (b.1923)

Ellsworth Kelly was born in Newburgh,
New York. He studied at the Pratt Institute,
New York between 1941 and 1942, the
Boston Museum of Fine Arts School from
1946 to 1947 and the Ecole des Beaux Arts,
Paris in 1948. His numerous commissions
include a mural for UNESCO, Paris in 1969
and a memorial for the United States
Holocaust Memorial Museum, Washington,
D.C. in 1993. Major retrospectives of his
work have been staged at the Museum of
Modern Art, New York (1973), the Whitney
Museum of American Art (1982) and the
Solomon R. Guggenheim Museum (1996).
He currently lives and works in upstate
New York.

20 The Fossil Garden

THE RITUAL SERIES, P12123–P12126 (incomplete)

1987
etching, aquatint, lithograph, woodcut, engraving,
drypoint and collage on paper
914 × 1003 mm
P12124

In 1987 Terence La Noue worked on *The Ritual Series*, a set of prints that uses several processes and techniques in order to echo the extraordinary effects of his vivid, multi-layered paintings. La Noue has long been interested in the artefacts, mythologies, rituals and spiritual aspects of non-Western and so-called 'primitive' cultures. His paintings incorporate the motifs and symbols of countless cultural traditions, and seek to explore our unconscious links with these distant civilisations. *The Ritual Series*, with individual titles such as *The Dreams of Gods* and *The Water Spirits*, continues this trajectory.

La Noue spent much of the 1970s travelling the world, and his subsequent work was greatly enriched by his expanded lexicon of symbols drawn from the places he visited. In her monograph on the artist, Dore Ashton argues that La Noue's passionate adherence to abstraction is inspired by its presence in the artefacts of many disparate cultures, past and present. His approach is highly eclectic, however, and no specific tradition dominates. La Noue's frequent use of discrete images set within the framework of a larger image suggests the framing of Tibetan *tankas* or Indian miniatures. Moreover, the dividing of paintings into two or more distinct sections is reminiscent of Japanese screens or religious icons.

Tyler's gift to Tate includes five prints from *The Ritual Series*, four of which are published in an edition of forty-two, with *The Dreams of Gods* alone being part of an edition of fifty. They combine such techniques as etching, aquatint, lithograph, woodcut, engraving and drypoint with collage elements. Most of the prints share a similar structure: a large main section of imagery that lies to the left or right of the paper, beside which is an enlarged, simplified motif that relates to it visually. A collage element is also attached in four of the prints: a small piece of paper with a discrete linear composition functions as an inset along the border of the principle image.

In the introductory essay to the catalogue *Terence La Noue: New Work* (1990), Barry Walker wrote that La Noue took to printmaking almost effortlessly, since his painting techniques had always seemed very similar to those of printmaking. Ashton has described his approach to painting in the following way: 'Everything is in a state of change as he works, applying his colours in shifting layers and manipulating various textures. The state of mind of the excavator, always on the threshold of discovery, was sustained.' (Dore Ashton, *Terence La Noue*, New York 1992, p.40.) She describes La Noue's excitement regarding the volume of new techniques available to him at Ken Tyler's studio when they embarked upon their collaboration. The techniques deployed in *The Ritual Series* – collage, over-printing, embossing – were so close to his painting that La Noue was able to proceed seamlessly from one to the other.
HD

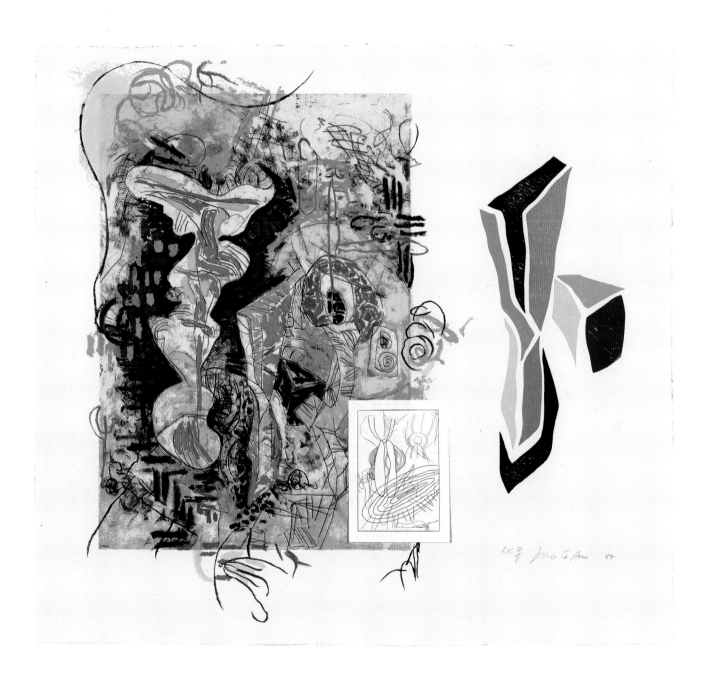

A.P. ⁹⁄₉ James Tatum 87

21 The Talking Drums

THE RITUAL SERIES, P12123–P12126 (incomplete)

1987
etching, aquatint, lithograph, woodcut, drypoint and collage
on paper
914 × 1003 mm
P12125

22 The Sorcerer's Apprentice

1982
mezzotint, woodcut, etching, aquatint, collage
and paint on paper
1245 × 1035 mm
P12121

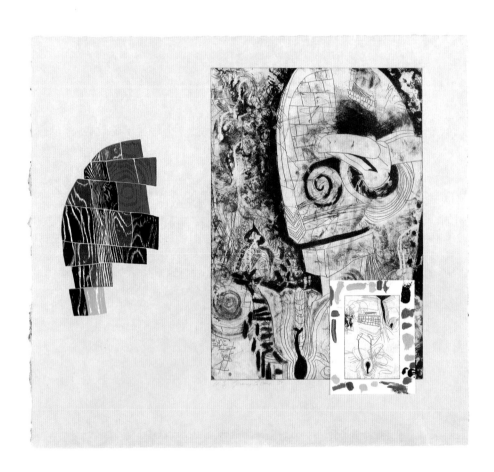

Terence La Noue (b.1941)

La Noue was born in Hammond, Indiana.
He studied at Ohio Wesleyan University,
Delaware from 1960 to 1964, the
Hochschule für Bildende Kunste, Berlin
from 1964 to 1965, and Cornell University,
Ithaca from 1965 to 1967. He has received
grants from the National Endowment for
the Arts (1972–3 and 1983–4), and the
John Simon Memorial Grant (1982–3 and
1984). His work is represented in the
permanent collections of major museums
including the Museum of Modern Art,
New York, the Solomon R. Guggenheim
Museum, the Whitney Museum of
American Art, The Brooklyn Museum, the
Museum of Fine Art, Houston, and the
Walker Art Center, Minneapolis. He
currently lives and works in New York City.

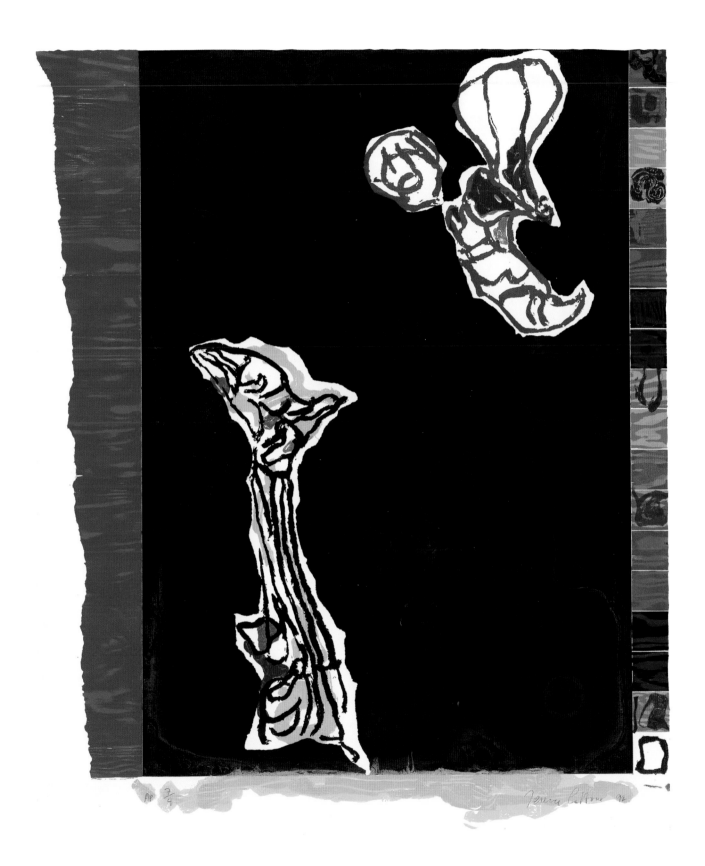

AP 7/9 Jeremy [signature] 96

23 American Indian Theme IV

1980
woodcut and lithograph on paper
724 × 712 mm
P12129

Roy Lichtenstein (1923 – 1997)

Lichtenstein was born in New York, where he lived and worked until his death. He studied at the Art Students League, New York in 1939 and at Ohio State University, Columbus from 1940 to 1943 and from 1946 to 1949. A major figure in the American Pop art movement, Lichtenstein is represented in the permanent collections of major museums including the Museum of Modern Art, New York, the Whitney Museum of American Art, the Art Institute of Chicago, the National Gallery of Art, Washington, D.C., and the Ludwig Museum, Cologne. Recent major retrospectives of his work have been staged at the Hayward Gallery, London (2004), the Contemporary Art Center, Cincinnati (1997), and the Solomon R. Guggenheim Museum (1993).

ROY LICHTENSTEIN

24 Reflections on Brushstrokes

1990
lithograph, screenprint, woodcut, collage
and embossing on paper
1460 × 1803 mm
P12128

25 Trees III

TREES SERIES, P12140–P12143 (incomplete)

1992
lithograph on paper
1365 × 2004 mm
P12142

Joan Mitchell worked on the ten lithographs that make up the *Bedford Series* during February and March of 1981. She continued to collaborate with Tyler Graphics on the production of the prints through to September of that year. The title of the series was inspired by the workshop that Tyler opened in 1974 in Bedford Village, New York. Within the series there are four distinct groups of prints (*Bedford, Sides of a River, Flower* and *Brush*) and each explores a particular motif or composition. All of the prints share the same dimensions and were printed on an offset lithography press from aluminium plates.

The prints in the *Bedford Series*, like much of Mitchell's work, take nature as their subject. The titles of the lithographs are generalised but descriptive, and although the images are heavily abstracted, traces of scenes or objects remain. In the *Sides of a River* prints, for example, dense bands of marks at the top and bottom of the paper suggest river banks. A less heavily worked area filling the centre of the image can be read as an expanse of water. Similarly, each of the three *Flower* prints incorporates an oval shape near the top of the image, which evokes the bloom of a flower. In spite of these figurative references and allusions to landscape, neither Mitchell's paintings nor her prints depict actual or observed places or things. Mitchell often only recognised the place or shape once the work was finished and she generally gave her works titles after they were completed.[1]

Early in her career Mitchell was influenced by the Abstract Expressionists working in New York, and the emphatic, gestural marks that fill her prints and paintings recall the work of artists such as Willem de Kooning and Franz Kline. The images in the *Bedford Series* are built up of layers of curving lines, vertical strokes and drips of colour, and the expressionistic qualities of the works suggest a quick and spontaneous way of working. In spite of the freely drawn compositions,

26 Sides of a River I

BEDFORD SERIES, P12144–P12151 (incomplete)

1981
lithograph on paper
998 × 712 mm
P12147

27 Sides of a River II

BEDFORD SERIES, P12144–P12151 (incomplete)

1981
lithograph on paper
1013 × 750 mm
P12148

however, the structure of the images was carefully planned. Mitchell herself once explained that 'the freedom in my work is quite controlled'[2] and this tension between abandon and control runs throughout the prints of the *Bedford Series*. She worked and reworked the drawings for her lithographs, and was equally rigorous in selecting their colours. Tyler was struck by her careful approach to making the prints:

> When I got a rare chance to see her drawing, the fluidity and strength of her movement was extraordinary. It wasn't Motherwell's automatism – it was considered and deliberate . . . she accepted everything quite slowly – normally colour was trial-and-error. If the drawing was wrong, she'd throw it out. She wouldn't even try to correct.[3]

Mitchell's interest in exploring the elements of the lithographic process is evident in the *Bedford Series* prints. There is considerable variation in the number of colours used for each print and she experimented with reusing certain plates in several of the works. Some patterns of lines are clearly repeated in the three prints of the *Sides of a River* group, for example. More remarkably, Mitchell also used plates from one group of prints in the making of another. The dark green shapes near the bottom corners of *Sides of a River III*, for instance, reappear in black in *Bedford III*. This particular kind of recycling is difficult to detect, especially in the more densely layered works of the *Bedford* group. Mitchell varied the number of plates she used for individual prints within the four groups, affecting the density of the marks on the page and the impact of the image as a whole. Her use of colour also significantly altered the mood of the images. The vivid yellow and green in *Sides of River II* give the work a lighter and more joyful feel than *Sides of a River I*, in which a wash of deep pink dominates.

If the prints in the *Bedford Series* expose Mitchell's interest in the lithographic process, they also demonstrate her desire to explore the physical qualities of the medium. Lithographic crayons and pencils are made of pigments blended with fatty materials and are used to make a grease image on the printing plate. Lithographic ink (or 'tusche') is similarly an oily mixture diluted with water or a solvent. Mitchell worked up her images on sheets of Mylar, and the slip of the greasy pigment on the drawing surface remains visible in many of these prints. The streaky quality of the broad black strokes in the centre of *Bedford III*, for example, suggests the oiliness of the lithographic crayon. Ultimately, Mitchell's *Bedford Series* prints place a modernist focus on the nature of the medium itself. In her introduction to the *Bedford Series* catalogue, the critic Barbara Rose succinctly explained: 'the greasiness, grittiness and oiliness of the lithographic crayon and the quicksilver liquidity of tusche are as much the "subjects" of [Mitchell's] lithographs as the loaded brushstroke is the "subject" of her paintings.'[4] KR

1 Linda Nochlin, 'A Rage to Paint', in *The Paintings of Joan Mitchell*, Whitney Museum of American Art, exh. cat., New York 2002, p.58.
2 Quoted in Nathan Kernan, 'The Presence of Absence', in *Joan Mitchell: Selected Paintings 1956–1992*, New York 2002, n.p.
3 Ken Tyler quoted in Jane Livingston, *The Paintings of Joan Mitchell*, New York 2003, p.46.
4 Barbara Rose, 'Joan Mitchell', in *Bedford Series: A Group of Ten Lithographs*, Bedford, New York 1981, n.p.

Joan Mitchell (1926 – 1992)

Joan Mitchell was born in Chicago. She studied at Smith College from 1942 to 1944, at the Art Institute of Chicago between 1944 and 1949 and at Columbia University in 1950. In 1955 she moved to France, where she lived and worked until her death. Solo shows of her work were staged at the Whitney Museum of American Art in 1974 and 1992. In addition she participated in major exhibitions including *Les Dernières années* at the Galerie nationale du Jeu de Paume, Paris (1994) and *Choix des peintures 1970–1982* at the Musée d'art moderne de la Ville de Paris (1982).

28 Pamela Running Before the Wind
with a Dutch Lighthouse

1998
lithograph on paper
1263 × 872 mm
P12153

Pamela Running Before the Wind with a Dutch Lighthouse revisits themes and motifs that have preoccupied Malcolm Morley since the early 1960s. It depicts a red and white sailboat in a turbulent bright-blue sea, hinting at impending disaster. A candy-striped lighthouse is improbably positioned in the top left-hand corner beyond which no horizon can be seen, rendering the composition flat and schematic with an undetermined viewpoint.

In the mid-1960s Morley began making 'superrealist' paintings that derived from mass-produced printed material such as colour postcards, travel brochures and glossy magazines. Although his depictions were extremely realistic, Morley's approach was abstract: he would transfer the source material to his canvas by means of a grid system, frequently covering the canvas so that only the tiny section on which he was working was visible, or he would paint the composition upside down. This enabled him to understand the work purely in terms of a coloured surface, preventing stylistic flourishes. The motifs that dominated throughout this period included images of cruise liners, sailboats, aeroplanes and lighthouses. Morley abandoned superrealism in

the 1970s, and in the 1980s he explored a gestural, neo-Expressionist approach to painting. However, the 1990s saw a return to his familiar motifs of boats and aeroplanes, together with his long-standing preoccupation with the conflation of pictorial planes and perspectival viewpoints.

Pamela Running Before the Wind with a Dutch Lighthouse is an example of this return to earlier concerns. Morley had first worked with Ken Tyler in 1981 and had produced a number of highly gestural prints depicting animals the following year. *Devonshire Cows* 1982, for example, combines both recognisable form and amorphous abstraction, and has a vigorous, painterly quality. *Pamela Running Before the Wind with a Dutch Lighthouse,* a thirteen-colour lithograph published in an edition of sixty, is one of a number of seascape and seaside prints that Morley made with Tyler in the 1990s. Others from this period, such as *Flying Cloud with Montgolfiére Balloon* 1998 and *Beach Scene with Parasailor* 1998, similarly recycle the images to which Morley compulsively returns: galleons, bi-planes, hot air balloons, etc, as well as testifying to the artist's lifelong formal concerns. HD

AP 14/14

Malcolm Mereby 98

65

29 Devonshire Cows

1982
lithograph on paper
1108 × 804 mm
P12155

Malcolm Morley (b.1931)

Morley was born in London. He studied at
the Camberwell School of Arts and Crafts
from 1952 to 1953 and at the Royal College
of Art from 1954 to 1957. In 1958 he moved
to New York, where he continues to live
and work. A major retrospective of his
work was staged at the Basel Kunsthalle
and the Whitechapel Art Gallery, London
in 1983 and the following year he was the
first recipient of the Turner Prize. His more
recent solo shows at major museums
include the Fundació la Caixa, Madrid
(1995) and the Musée nationale d'art
moderne, Centre Georges Pompidou,
Paris (1993).

30 Goat

1982
lithograph on paper
799 × 1029 mm
P12159

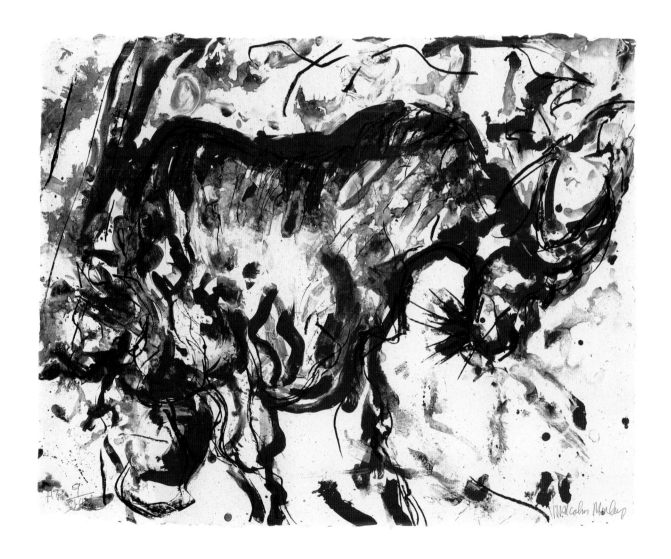

31 Game of Chance

1987
lithograph, aquatint, collage and paint on paper
876 × 699 mm
P12161

When Ken Tyler moved to the East Coast in 1974 he established his studio just four miles from Robert Motherwell's home, which enabled the two to work especially closely. In 1983 Tyler also became the artist's print dealer and distributor. Motherwell enjoyed the camaraderie of the workshop and had developed a taste for collaborative working. However, he was singularly uninterested in printmaking processes. Tyler has commented:

> The technique and all the 'cooking' . . . doesn't matter to him . . . There isn't the foggiest idea of how it's going to be technically – whether it's going to be a single colour or a ten-colour print, whether it's going to be as you see it on the floor in the drawing stage, or later with other things collaged on top; that's exciting, because it's printmaking without any kind of programme.[1]

Motherwell and Tyler collaborated on the artist's book El Negro from 1981 to 1983, and it has been described as the high point of a working partnership that dated back to 1973. It comprises seventeen lithographs, which accompany the Rafael Alberti poem, El Negro Motherwell, and was published in an edition of fifty-one. El Negro is thus the result of not one but two significant relationships. In addition to consolidating the collaborative partnership with Tyler, it also marked an important dialogue between Motherwell and Alberti.

In 1972 Motherwell produced his first artist's book, A la pintura, when working with printmaker Tatyana Grosman at Universal Limited Art Editions (ULAE). Five years earlier he had come across a book of poems by Alberti and had been deeply moved by a series of poems in homage to the medium of painting, titled A la pintura. Motherwell commented later: 'I had found the text for a livre d'artiste . . . a text whose every line set into motion my innermost painterly feelings.'[2] He subsequently spent a great deal of time and energy producing a series of etchings in response to the poems. A la pintura was published in 1972 and was both a technical and critical success.

Although a dialogue between Motherwell and Alberti was sparked in 1967, they did not meet until thirteen years later. In April 1980 a large retrospective of Motherwell's work opened in Madrid. An art historian was invited to give a lecture on the work, which was to be followed by some words from the artist. However, an unplanned event unfolded: 'After the art historian's speech was over, and before he himself was about to speak, Robert Motherwell was astonished to see Rafael Alberti, whom he had never met, come forward from his seat in the auditorium and in an electrifying voice read a poem, El Negro Motherwell (Motherwell Black), that he had written for the occasion.'[3] The idea for the publication El Negro was established during a lengthy conversation between the two men, which took place the following morning.

Motherwell returned from Madrid in 1980 with the idea for El Negro. He was concerned, however, about the limitations of a book with identically sized pages throughout. Tyler's solution to this obstacle was to include several gatefold pages, which would allow for a more varied book format. The simple and spontaneous feel of El Negro belies the complex means of its evolution. Motherwell began by drawing directly on Mylar and acetate sheets, which were then transferred to aluminium lithography plates. Frequently working on Sundays to ensure the absence of distraction that the artist needed, they developed the book over time through endless permutations of imagery, ink colours, binding styles and choice of typeface. Tyler exploited the full range of his printmaking techniques in order to achieve the impression of simplicity and immediacy that Motherwell sought.

El Negro has been described as having the feel of a sketchbook. This is achieved in part through

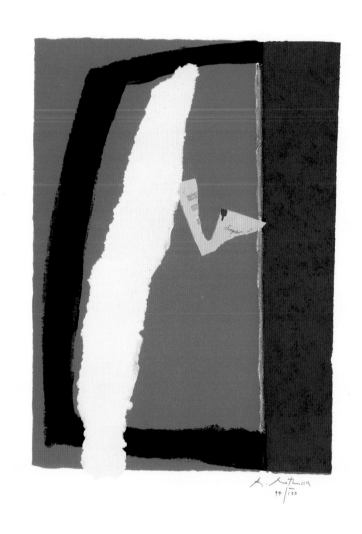

32 America–La France Variations II

1984
lithograph and collage on paper
1156 × 737 mm
P12164

Motherwell's extensive inclusion of his own handwriting in the images, as well as his use of automatic gestures. He had been interested in Surrealism-inspired psychic automatism since the early 1940s, when he had discussed the subject with Jackson Pollock, and he had experimented with it for many years. *El Negro* is also remarkable for its emphatic and resonant use of black. Motherwell consistently exploited the emotional impact of black in his painting and printmaking. It has been described as marking an imperative throughout his oeuvre.[4] Indeed, in 1980 an exhibition titled *Robert Motherwell & Black* was staged in Connecticut, the same year that Rafael penned his poem *El Negro Motherwell*, which celebrates the artist's expressive and poignant use of the colour. Motherwell commented on this aspect of his work in 1974:

When I use black, I don't use it the way most people think of it, as the ultimate tone of darkness, but as much a colour as white or vermillion, or lemon yellow or purple, despite the fact that black is no colour, non-being, if you like. Then what more natural than a passionate interest in juxtaposing black and white, being and non-being, life and death?[5]

El Negro is printed on luxurious handmade paper, and the end result provides an extremely sumptuous experience for the viewer. In the year after *El Negro* was published, Motherwell was quoted as saying: 'To work with such craftsmen has been a joy and a welcome break from the essential solitude in which the artist works . . . no modern artist is an island – individual as he is . . . he works and lives owing, in part, to the givingness – and skills of others.'[6] H D

1 *The Art of Collaboration: The Big Americans*, exh. cat., National Gallery of Australia, Canberra 2002, p.87.
2 Siri Engberg and Joan Banach, *Robert Motherwell: The Complete Prints 1940–1991, Catalogue Raisonné*, Walker Art Center, Minneapolis 2003, p.21.
3 Jack Flam, *Robert Motherwell: El Negro*, New York 1983, p.6.
4 Stephanie Terenzio, *Robert Motherwell & Black*, exh. cat., The William Benton Museum of Art, Connecticut 1980, p.51.
5 Ibid., p.42.
6 Engberg and Banach 2003.

Robert Motherwell (1915 – 1991)

A major figure of the Abstract Expressionist movement, Motherwell was born in Aberdeen, Washington in 1915. He studied at Stanford University from 1932 to 1937, at Harvard University from 1937 to 1938 and at Columbia University from 1940 to 1941. He began exhibiting his paintings in New York in the 1940s, notably in a solo show at Peggy Guggenheim's Art of This Century Gallery in 1944. Major retrospective exhibitions of his work include the Kunsthalle Düsseldorf (1976), the Royal Academy of Arts, London (1978) and the Albright-Knox Art Gallery, Buffalo, New York (1983). He died in Cape Cod, Massachusetts in 1991.

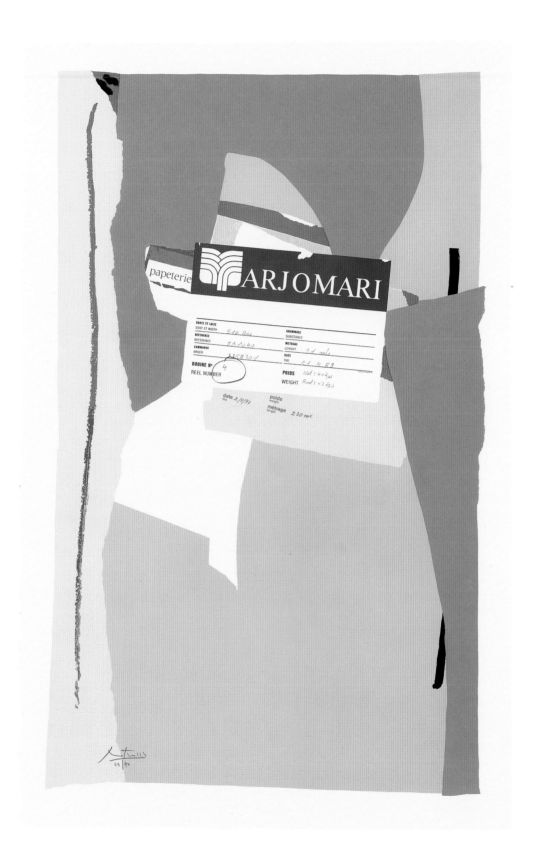

33 La Guerra II

1980
lithograph on paper
704 × 997 mm
P12197

34 El General

1980
lithograph on paper
994 × 698 mm
P12199

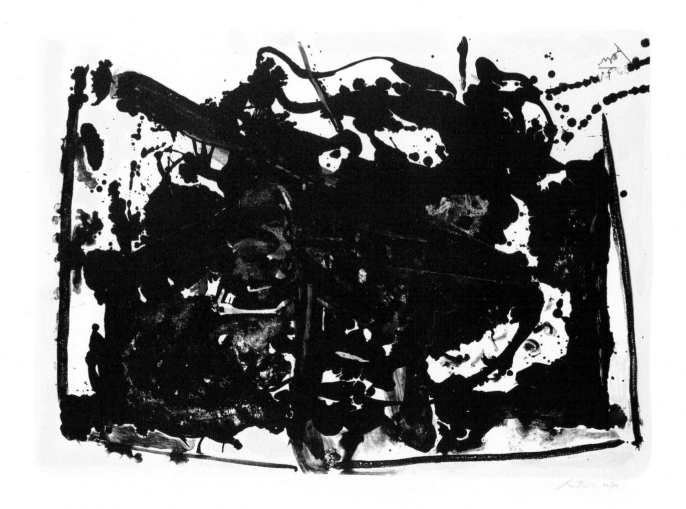

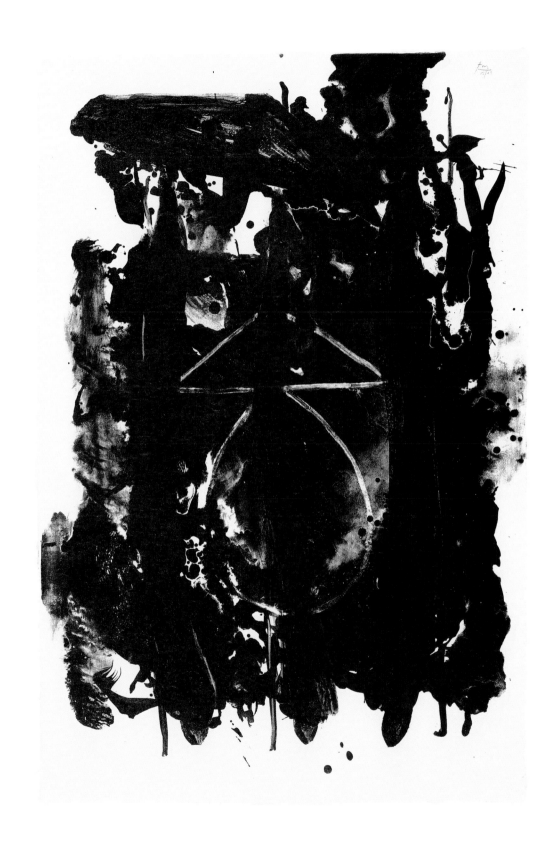

35 Second Thoughts I

1995
linocut on paper
315 × 238 mm
P12206

Seconds Thoughts is a suite of six linocuts made in 1995, immediately after the completion of a series of six sculpture multiples to which they closely relate, which are collectively titled *On the Other Hand*. The sculpture multiples were also the result of a collaboration with Ken Tyler, which evolved over a three-year period, beginning with a trip to Japan in 1992. Initially, the structures were made from papier-mâché using Japanese Kozo sheets, but the project later became increasingly complex. The end products include such diverse materials as industrial felt and Japanese bamboo tea whisks, and techniques including polyester and aluminium casting, gilding, bandaging, sculpting and painting. Each work consists of a single, simple form that twists and loops back on itself in order to produce a closed curvilinear structure. Their ambiguously organic yet high-tech shapes refer to a multitude of sources ranging from science fiction to laboratory testing.

While the sculpture multiples are technically complex, the *Second Thoughts* prints, which took roughly three months to complete, are relatively straightforward. Adam D. Weinberg has described them as having an 'effortless and childlike honesty'.[1] Indeed, Newman himself has likened them to a previous series of linocuts that he has called 'potato prints' because of their rawness and unpolished appearance. Newman worked on the linoleum blocks at both his Manhattan studio and the Tyler Graphics workshop. When Tyler had printed the first set of black proofs on various kinds of paper, Newman opted for Natural Okawara, a machine-made paper. He then proceeded to draw directly onto the proofs. The results were sifted through and he used selected examples as models for the second-colour linoleum blocks.

While the forms depicted in the prints relate closely to the structures of the editioned sculptures, they do not illustrate them. Rather, they suggest provisional shapes in the process of evolution, on the cusp of coherence. By contrast, the multiples as three-dimensional objects are of necessity fully resolved. Despite the simplicity of their execution, the range of references in each print is prodigious. Not only are certain sections of *Second Thoughts III* reminiscent of biological or geological diagrams but, as Weinberg has pointed out, the work also suggests German Expressionist prints, Celtic manuscripts and classical architectural decoration. Moreover, in *Second Thoughts IV*, he has detected the influence of Tibetan mandalas, Surrealist automatic writing and topological diagrams.[2]

Newman layers so many references that they end up cancelling each other out. Viewers are invited to unravel the meaning in his work and yet their attempts to do so are invariably thwarted. The spectator is thus encouraged to relate to the work on a more direct level, taking pleasure in forms that defy explanation in terms of subject matter. As Weinberg says: 'In trying to unravel his sources, one realizes that they are too plentiful and ambiguous to pin down, and that knowledge of them isn't crucial to the ultimate success of the work. Despite all the clues provided, art such as Newman's is about losing track of origins.'[3] HD

1 *John Newman: On the Other Hand: Sculpture Multiples: Second Thoughts: Print Series*, Tyler Graphics Ltd, Mount Kisco, New York 1995, p.9.
2 Ibid., p.6.
3 Ibid., p.8.

John Newman (b.1952)

Newman was born in 1952 in Flushing, New York and currently lives and works in New York City. He participated in the Independent Study Program at the Whitney Museum of American Art in 1972 and studied at Oberlin College in 1973 and the Yale School of Art in 1975. He is predominantly known as a sculptor; his work is represented in major collections including the Whitney Museum, the Metropolitan Museum, the Museum of Fine Arts, Boston, and The Brooklyn Museum. In 1995 he received a grant from the New York Foundation for the Arts.

AP ⁵⁄₈ I [signature]
 1995

36 Waccabuc I

1992
lithograph and paint on paper
1035 × 1346 mm
P12224

Hugh O'Donnell (b.1950)

O'Donnell was born in London in 1950.
He studied at Camberwell College of Art
from 1968 to 1969, Falmouth School of
Art from 1969 to 1972, Birmingham School
of Art from 1972 to 1973, Gloucestershire
College of Art from 1973 to 1974, the
Kyoto University of the Arts from 1974 to
1976 and the Royal College of Art from
1976 to 1979. He lives and works in London.
His work is included in major collections
including the Metropolitan Museum,
the National Gallery, Washington, D.C.,
the Museum of Modern Art, New York,
the Solomon R. Guggenheim Museum
and the Victoria and Albert Museum.

37 Odyssey

2000
screenprint on paper
786 × 663 mm
P12226

Sam Posey (b.1944)

Posey was born in New York in 1944. He is best known as a Grand Prix racing driver. Since retiring from the track he has worked as a television sports commentator and become a qualified architect, designing his own home and other buildings. He is also an accomplished artist. He currently lives in Sharon, Connecticut.

JAMES ROSENQUIST

38 Space Dust

WELCOME TO THE WATER PLANET
P12233–P12241 (incomplete)

1989
relief, lithograph and collage on paper
1689 × 2673 mm
P12233

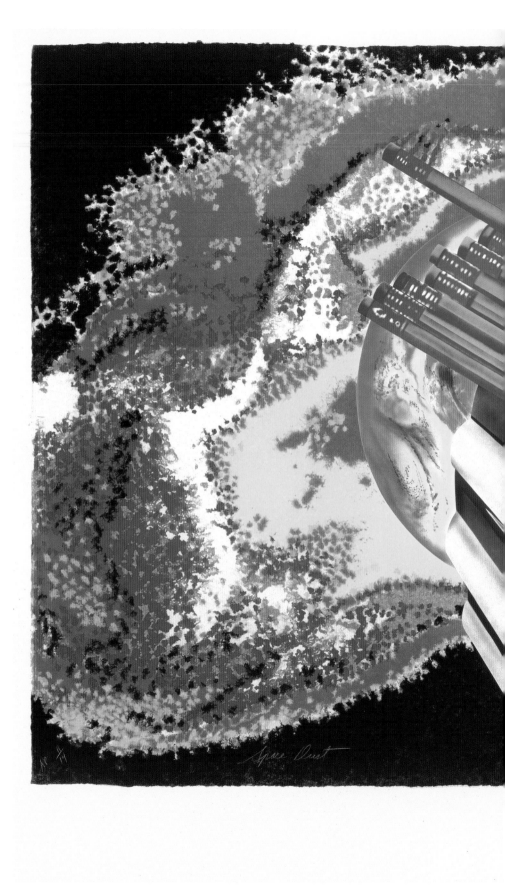

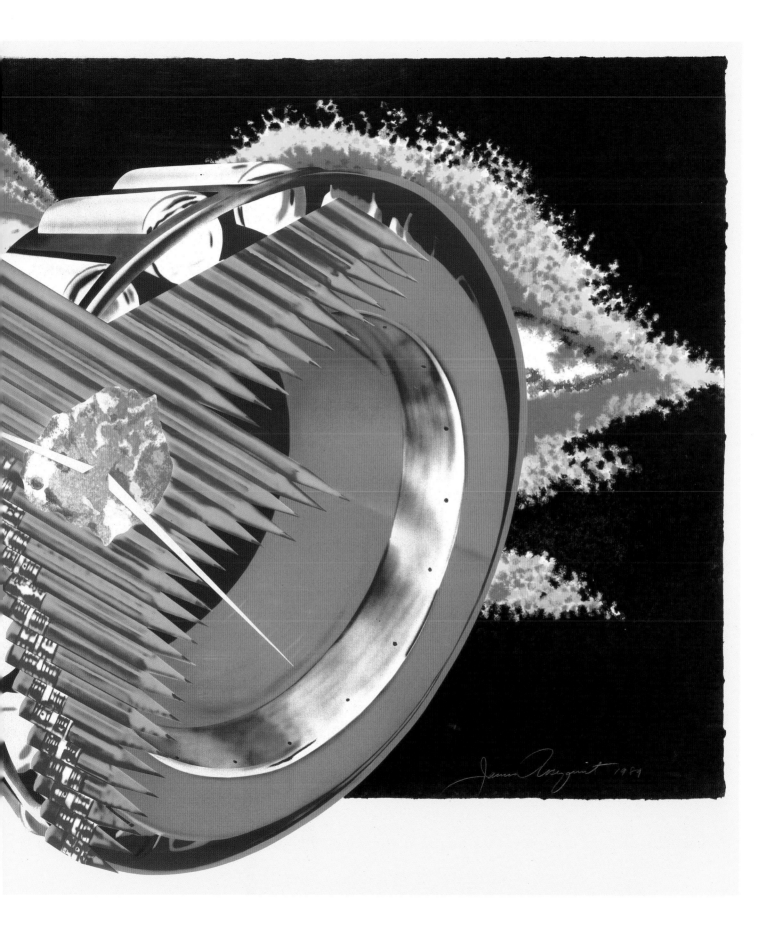

39 Skull Snap

WELCOME TO THE WATER PLANET, P12233–P12241 (incomplete)

1989
relief, lithograph and collage on paper
1511 × 1511 mm
P12239

Between September 1988 and November 1989 James Rosenquist worked with Ken Tyler at his Mount Kisco (New York) studio on a group of nine prints that comprise the *Welcome to the Water Planet* series. The prints address a recurring theme in Rosenquist's oeuvre: the ecological impact of consumer culture on the natural environment. The 'water planet' of the title is a reference to the Earth, and the prints imagine the planet as it might be seen from outer space.

As a painter, Rosenquist is known for his vast, at times enveloping canvases – his early experience as a billboard painter helped to hone the skills and techniques required to paint on such a large scale. The considerable size of paintings such as his *F111* 1964–5, at over twenty-six metres long, for example, has a calculated effect on the viewer's perception. As Rosenquist has explained, 'the reason for bigness isn't largeness, it's to be engulfed by peripheral vision; it questions the self and questions self-consciousness'.[1] When he began to collaborate with Tyler on the *Water Planet* series, he made clear his ambition to make prints as big as his paintings. With the workshop in Mount Kisco, Tyler was equipped to meet this challenge and he immediately commissioned a new mould, known as a 'deckle box', big enough to make the large sheets of handmade paper required by the project. As ideas for the work developed, Tyler also designed new lifting and drying equipment to accommodate the paper's dimensions. The two largest editions in the *Water Planet* series (*The Bird of Paradise Approaches the Hot Water Planet* and *Time Door Time D'Or*) use abutting sheets of the handmade paper.

All of the prints in the *Water Planet* series combine broad saturated areas of colour with sharper, more detailed imagery. In *The Bird of Paradise Approaches the Hot Water Planet*, the first print in the series, a bird and three fragmented images of faces are superimposed over a background of hot pinks, reds and oranges that bleed together towards the bottom of the image. The bird is rendered in silhouette and the floral pattern that fills the shape echoes a fuzzier flower shape that extends across the central area of the background. Near the bottom of the image a pair of blue eyes gazes out, and beneath these another eye and pink lips are visible. A further sliver of an eye and a red mouth are stretched across the join between the two sheets of paper. The image calls to mind a violent eruption, and the overlapping of figurative imagery and abstract shapes is typical of the prints in this series.

Rosenquist and Tyler began work on all of these prints using a small preparatory collage as a guide. Rosenquist wanted to achieve painterly effects similar to those in his works on canvas, and the pair decided that a combination of printmaking techniques would be required in order to achieve the contrast between densely coloured backgrounds and sharply rendered figurative elements. Coloured paper pulp was used for the coloured backgrounds, lithography for the figures in the foreground. *The Bird of Paradise* has been described as a testing ground for the techniques used throughout the *Water Planet* series. This applied in particular to the refinement of the application of the coloured paper pulp. Initially Rosenquist used a set of metal stencils (similar to cookie cutters), pouring the paper pulp onto the surface of the handmade paper. This approach proved unsatisfactory since the liquid was difficult to control and the results were messy and unpredictable. Tyler developed another method for applying the paper pulp using 'pattern pistols' to spray the coloured pulp onto the wet handmade paper. The pistols had the advantage of allowing Rosenquist to work quickly and evenly across large areas, spraying the coloured pulp through stencils laid on top of the paper. A separate stencil was used for each colour. For Rosenquist, this innovation in technique brought the process one step closer to painting. In a film documenting the making of the *Water Planet* series he explained:

The wonderful thing about paper pulp is the colour. If you take a magnifying glass you'll see a little fuzz rising like smoke off the surface of this handmade paper . . . it's like doing giant watercolours and letting this watercolour seep together just at the perfect moment and then stopping it.[2]

With the exception of *Caught One Lost One for the Fast Student or Star Catcher*, all the prints in this series incorporate coloured paper pulp combined with collaged lithographic elements. For *Caught One Lost One* the process was reversed – the background and image were printed using lithography and the small collaged element in the foreground was sprayed with layers of coloured paper pulp. Two other prints from the series (*Skull Snap* and *Skull Snap State* 1) also incorporate relief printing. The prints in the *Welcome to the Water Planet* series are remarkable for their complexity of composition and for their weaving together of the densely coloured sprayed paper pulp and imagery printed using a lithography press. The hand application of the sprayed paper pulp in particular distinguishes these prints and it is a technique that Rosenquist and Tyler continued to explore in the monumental print *Time Dust*, made during the summer of 1992. Elaborate hand-finishing has become a hallmark of Rosenquist's recent work in print and he welcomes the slight variations that this creates between editions. For him, each of the prints is 'a little bit different. It's almost like the making of a rug – they're all a little different but there's a similar design.'[3] K R

1 Quoted in Judith Goldman, 'Whenever You're Ready, Let Me Know', in *Welcome to the Water Planet*, exh. cat., Tyler Graphics Ltd, Mount Kisco, New York 1989, p.17.
2 Quoted in Ken Tyler, 'The Paper Dance', in *Contemporary Master Prints from the Lilja Collection*, Vaduz, Liechtenstein 1995, p.291.
3 Quoted in Seth Schneidman and Maryte Kavaliauskas, *Welcome to the Water Planet* (film), New York 1989.

JAMES ROSENQUIST

40 Where the Water Goes

WELCOME TO THE WATER PLANET
P12233–P12241 (incomplete)

1989
relief, lithograph and collage on paper
2610 × 1473 mm
P12237

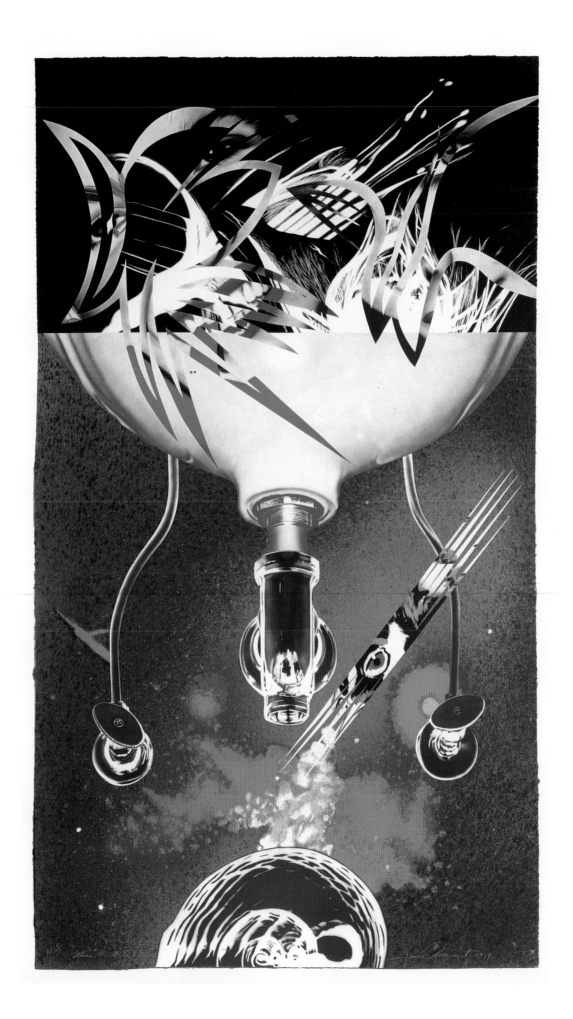

41 Time Door Time D'Or

WELCOME TO THE WATER PLANET
P12233–P12241 (incomplete)

1989
relief, lithograph and collage on paper
2477 × 3048 mm
P12234

James Rosenquist (b.1933)

Rosenquist was born in Great Forks, North Dakota in 1933. He studied at the University of Minnesota from 1952 to 1955 and at the Art Students League, New York in 1955. He was one of the most influential figures of the American Pop Art generation. Major retrospectives of his work took place at the Whitney Museum of American Art in 1972, at the Albright-Knox Art Gallery, Buffalo, New York in 1985 and at the Solomon R. Guggenheim Museum in 2003. He became a member of the American Academy and Institute of Arts and Letters in 1987. He continues to live and work in New York City and Aripeka, Florida.

42 Fast and Slow

HIGH AND LOW
P12243–P12247 (incomplete)

1994
lithograph and woodcut on paper
1423 × 993 mm
P12244

David Salle (b.1952)

Salle was born in Norman, Oklahoma in 1952. He studied at the California Institute of the Arts between 1973 and 1975. He currently lives and works in New York City and Long Island. His work is included in the permanent collections of major museums including the Whitney Museum of American Art, the Solomon R. Guggenheim Museum and the Museum of Contemporary Art, Los Angeles. Solo shows of his work have been staged at de Appel, Amsterdam (1977), Mary Boone Gallery, New York (1981), Akira Ikeda Gallery, Tokyo (1983), the Whitney Museum, New York (1986) Galerie Bruno Bischofberger, Zurich (1987), Larry Gagosian, New York (1991), Galerie Michael Werner, Cologne (1994) and the Stedelijk Museum, Amsterdam (1999).

DAVID SALLE

43 High and Low

HIGH AND LOW
P12243–P12247 (incomplete)

1994
lithograph, woodcut and
screenprint on paper
1435 × 1137 mm
P12243

44 Two Birds, Woodcock I

1978
lithograph on paper
527 × 617 mm
P12251

45 Bull-Pen

1984
woodcut, etching, aquatint and collage on paper
1022 × 1061 mm
P12250

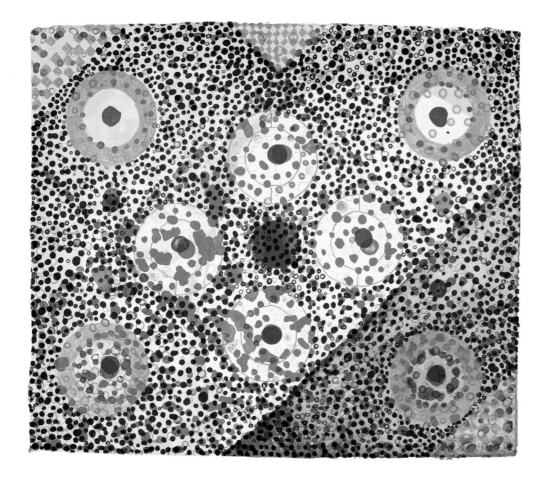

Alan Shields (b.1944)

Shields was born in 1944 in Herington, Kansas. He studied at Kansas State University, Manhattan between 1963 and 1966. He currently lives and works in Shelter Island, New York and is primarily known for his grid-based collages. His work is included in the permanent collections of major institutions including the Museum of Modern Art, New York; the Art Institute of Chicago; the Cleveland Museum of Art; the Hirschhorn Museum and Sculpture Garden, Washington, D.C., and the Museum of Fine Arts, Boston. His solo shows have included the Brooks Memorial Art Gallery, Memphis, Tennessee (1983), Galerie Andre Emmerich, Zurich (1984), Cleveland Center for Contemporary Art (1986) and Paula Cooper Gallery, New York (1988).

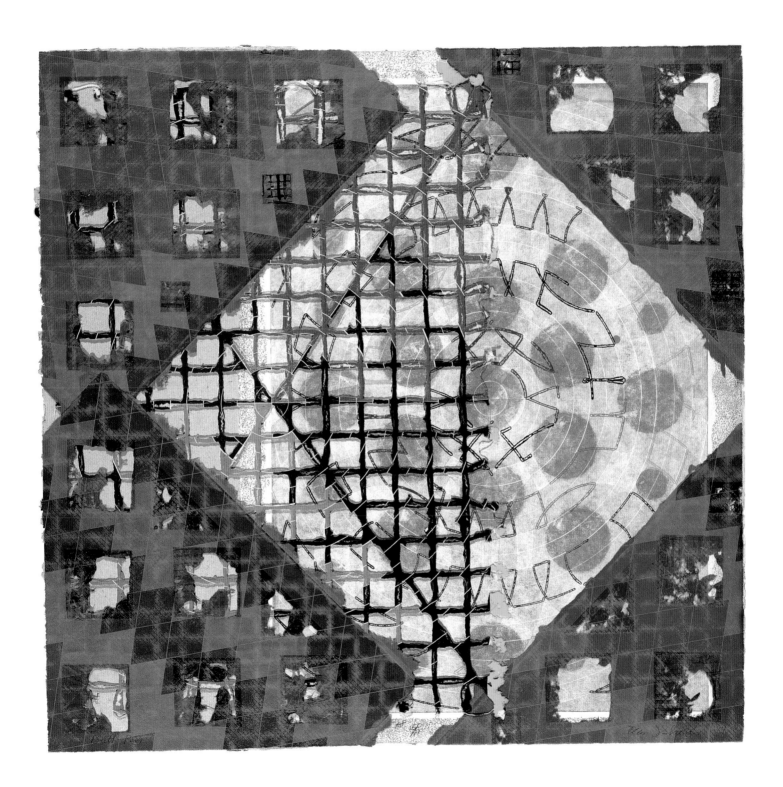

46 Pix

FIELDS AND STREAMS
P12252—P12258 (incomplete)

1982
aquatint, lithograph and drypoint on paper
480 × 390 mm
P12253

Richard Smith (b.1931)

Smith was born in Letchworth,
Hertfordshire in 1931. He studied at the
Luton School of Art from 1948 to 1950,
St. Albans School of Art from 1952 to 1954
and the Royal College of Art from 1954
to 1957. His solo shows have included the
Whitechapel Art Gallery, London (1966),
the Museum of Modern Art, Oxford
(1972), the Tate Gallery (1975) and the
Walker Art Center, Minneapolis (1979).
He was awarded the grand prize at
the São Paulo Bienal in 1966 and the
Commander of the British Empire in 1971.
He currently lives and works in New York.

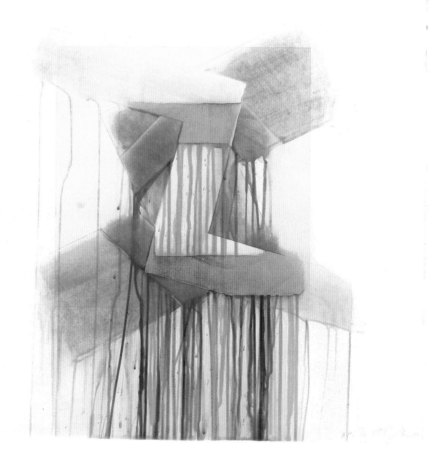

RICHARD SMITH

47 Pix, State I

FIELDS AND STREAMS
P12252–P12258 (incomplete)

1982
aquatint and drypoint on paper
486 × 395 mm
P12254

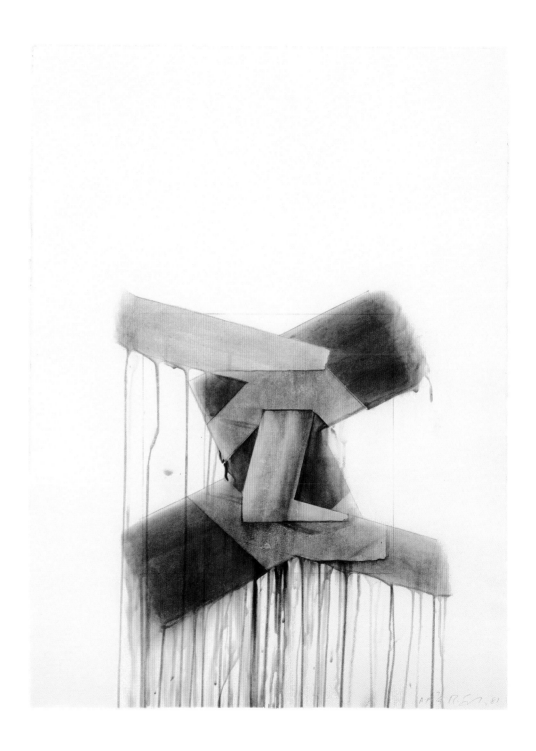

48 Excalibur

1986
relief, woodcut and mezzotint on paper
1066 × 412 mm
P12259

T.L. Solien (b.1949)

Solien was born in Fargo, North Dakota in 1949. He received a Bachelor of Arts from Moorhead State University, Minnesota in 1973 and a Master of Fine Arts from the University of Nebraska, Lincoln in 1977. His work is represented in the permanent collections of major institutions including the Whitney Museum of American Art, the Art Institute of Chicago and the Walker Art Center, Minneapolis. He has participated in large-scale group shows including the 1983 Biennial Exhibition at the Whitney Museum of American Art, the 39th Biennial Exhibition of American Painting at the Corcoran Museum, Washington, D.C. (1985) and *Avant-Garde in the Eighties* at the Los Angeles County Museum of Art (1987). He currently lives and works in Madison, Wisconsin.

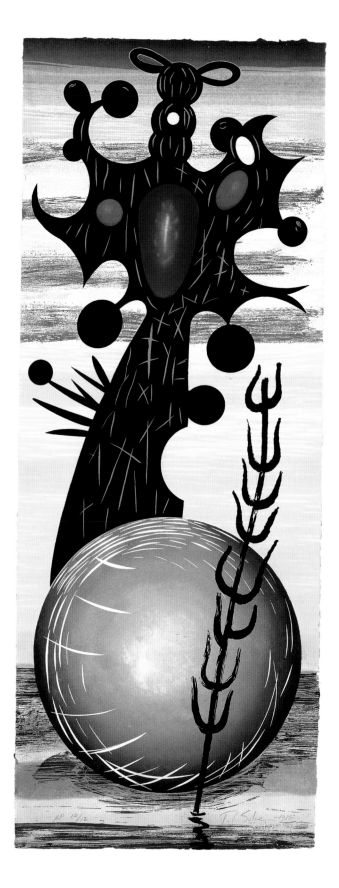

49 Psyche: The Blue Martin

1985
woodcut, aquatint and etching on paper
579 × 572 mm
P12260

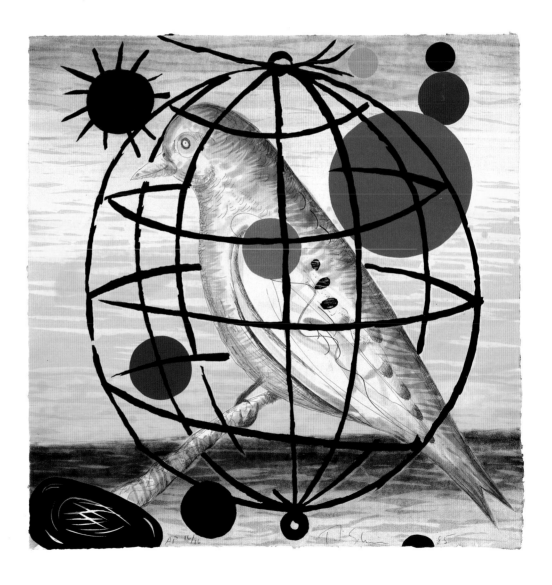

50 those from away IV

1989
linocut and paint on paper
521 × 464 mm
P12310

Steven Sorman first collaborated with Ken Tyler in 1984. Since then he has worked with Tyler Graphics on a number of projects, even travelling to Japan with Tyler in 1992 to produce a series of elaborate handmade Japanese papers for the *Rumors of Virtue* series. Like Tyler, Sorman takes an experimental approach to printmaking, combining different techniques, materials and types of paper. For Sorman, this way of working is an entirely practical solution, enabling him to make the richly layered and complex prints for which he has become known. He argues:

> If you're working on a lithograph and need a mark of a different character there's no problem whatever in switching media in midstream . . . Each particular print technique has its own inherent qualities and limitations. I find it quite exciting to combine them, not just for the sake of combining them but to do the work as pragmatically as possible.[1]

Another hallmark of Sorman's prints is the application of hand-finished or hand-applied elements in many of his works. The *inside weather* series, on which he worked at Tyler Graphics in 1997–8, combines hand-painted passages with lithography, screen printing, relief printing, bronzing and collage. There has long been an element of exchange between Sorman's painting and printmaking, and the *inside weather* series takes a series

of paintings from 1996 as its starting point. The prints in this series are expansive and filled with overlapping imagery. Organic shapes are layered under spots of colour and spiralling lines that evoke marine life or strands of DNA. In *as remembered*, for example, the central section is occupied by a ghostly shape resembling a pair of sea shells or bones. Flanking this section are darker areas in which rectangular shapes have been collaged over looping arabesques and gestural marks.

The juxtaposition of organic and geometric shapes is a compositional device that Sorman often employs. In works such as *Now at First and When* and *Years and When*, both made in 1985, squares and rectangles are layered over abstract patterns punctuated by images of feet and hands. Translucent papers collaged onto the prints act as veils, and the surfaces of the works are like palimpsests in which only fragments of images remain visible. The titles of these two works suggest an interest in addressing issues of memory and the passage of time, themes that emerge in many of Sorman's works. The allusive titles he chooses for his works are often what he describes as 'indications of process', making reference to how and when a work was made. They are also intended to be hints to the viewer, as Sorman explains: 'They are little doors into the pieces themselves.'[2] KR

1 Pinky Kase, Interview with Steven Sorman in *Vignette: Prints by Steven Sorman*, Kansas City 1989, unpaginated.
2 Ibid.

Steven Sorman (b.1948)

Sorman was born in Minneapolis in 1948. He received a Bachelor of Fine Arts degree from the University of Minnesota, Minneapolis in 1971. In 1982 he received the Rockefeller Foundation Studio Fellowship in Paris. His work is included in the permanent collections of major institutions including the Art Institute of Chicago; the Museum of Contemporary Art, Chicago; the Whitney Museum of American Art and the Museum of Modern Art, New York. His solo exhibitions have included Klein Art Works, Chicago (1991 and 1996), the Wetterling Gallery, Stockholm (1993), and Flanders Contemporary Art, Minneapolis (1997).

51 difference in ages – iv

1998
monotype, lithograph, mezzotint,
collage and paint on paper
464 × 406 mm
P12317

52 difference in ages – iii

1998
monotype, lithograph, mezzotint,
collage and paint on paper
464 × 406 mm
P12316

53 those from away VII

1989
linocut and paint on paper
1168 × 807 mm
P12313

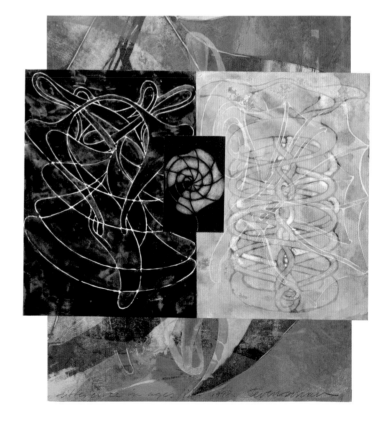

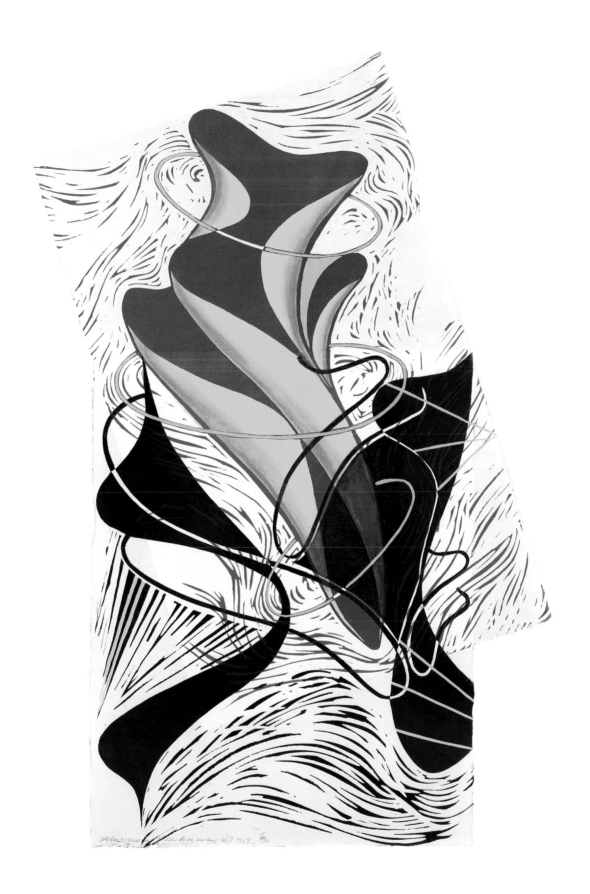

54 Stranz

1999
screenprint on paper
1907 × 1056 mm
P12325

Frank Stella worked on the *Circuit Series* and the *Swan Engraving Series* concurrently from 1980 to 1984. They marked a radical departure in his approach to printmaking, and transformed his subsequent work in this medium. Stella had been making prints with Ken Tyler since 1967, but had become disenchanted with his own printmaking efforts. When he embarked on the *Circuits* prints he immediately recognised the possibilities that were being opened up to him. Stella has since described this moment as a parting of the 'Red Sea of Printmaking Depression'.[1]

From 1967 until mid-1980, Stella had produced over a hundred print editions, most of which stemmed directly from his paintings. However, with the *Circuit Series* and the *Swan Engravings*, the way in which his paintings and prints related to each other was fundamentally changed. Both series connect to a number of relief-paintings, collectively titled *Circuits*, on which Stella worked between 1980 and 1984. They were assertive, colourful reliefs that appeared to leap off the wall and occupy the viewer's space. The *Circuits* comprised ninety-five paintings and were individually named after famous race tracks from around the world.

While working on the cut-out aluminium shapes for the *Circuits* paintings at the Swan Laser Die Company in Connecticut in early 1981, Stella noticed a large sheet of plywood that had been used as a backing board for the cutting out of shapes for the relief. After boring through the aluminium sheets, the router's bit had scored the plywood backing time and again, leaving countless overlapping outlines of cut-out shapes. Stella was struck by the beauty of this found drawing with its random, looping arabesques. He immediately saw not only its connection to painting, but also its obvious link to printing:

I loved the idea that simply inking the surface of the plywood board would produce a web of white lines, if one only pressed a piece of paper

against it . . . A tremendous feeling of freedom was triggered by the realisation that I didn't have to make prints after the paintings . . . The prints and paintings could share the same ideas, yet each could develop in its own way. It was a situation that seemed to guarantee a fruitful future, one full of possibilities.[2]

The *Circuit Series* was Stella's first incursion into intaglio and relief printing (he had peviously focused on lithography and screen-printing). While the backing boards formed the basis of the series, Stella introduced additional processes, frequently juxtaposing deliberate hand-carving with the random machine-generated lines, as well as having some of the original boards recut in birchwood or pine. He also used transparent acetate sheets placed onto the woodblocks, tracing or revising their patterns for the production of direct or photo-etched magnesium plates. Each *Circuits* print is richly layered with visual information and different techniques. As well as incorporating etching, engraving and screen printing, Stella contrasted the swirling lines of the backing boards with fields of intense colour, often printed on the large, multicoloured sheets of handmade paper specially formulated for this series by Tyler. With their kaleidoscopic effects and ambiguous spatial tensions, the *Circuits* works produced Stella's first prints to rival his paintings in terms of visual presence and complexity.

It was Stella's unorthodox recycling of scrap material that spawned his other print series of this period, the *Swan Engravings*. Like the *Circuits* prints, these were built out of material discarded from the *Circuits* relief paintings. Shapes for the *Circuits* reliefs were cut by machine, generating off-cuts of metal as by-products. Stella collaged the salvaged off-cuts on a plywood backing in order to build up the printing plate. He reworked the metal shards with etched lines, with engraving and areas of open biting, as well as incorporating

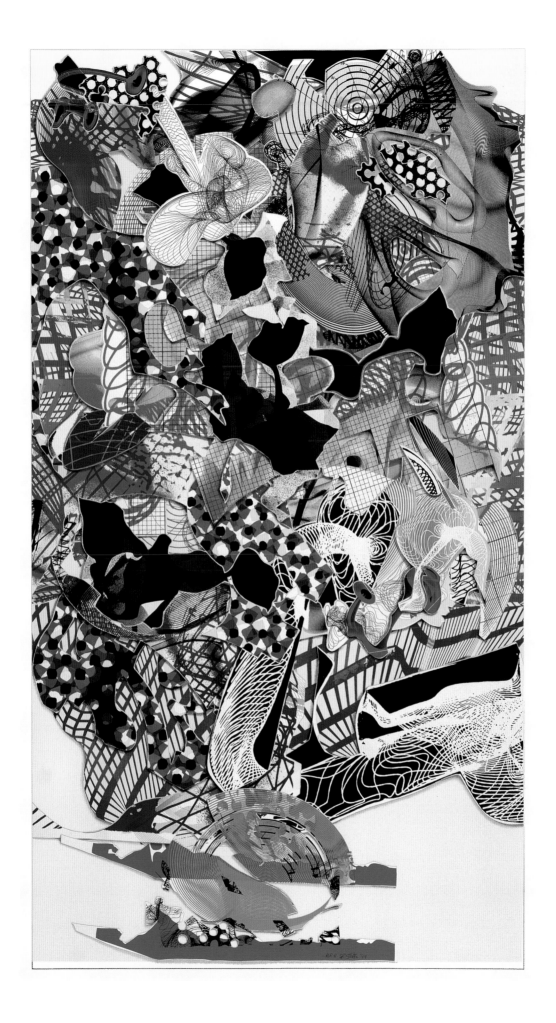

55 Swan Engraving I

SWAN ENGRAVING SERIES, P12367–P12369 (incomplete)

1982
etching on paper
1667 × 1285 mm
P12367

freshly cut shapes together with found commercial plates depicting lacy tablecloths. Named after the Swan Engraving factory where the material was gathered, the collaged plates were inked and wiped for intaglio and relief printing. Unlike the *Circuits* prints, where the visual information tends to be layered, the *Swan Engravings* presents resolutely fragmented surfaces, with each plate consisting of between six and fifty irregularly shaped magnesium scraps. In the *Swan Engravings*, Stella eschewed the rich colour of the *Circuits* prints, favouring the drama of black ink and the powerful tonal range it can achieve.

The *Circuits* prints and the *Swan Engravings* represent Stella's first extensive use of the found object. The *objet trouvé* immediately found its way into Stella's metal-relief constructions, indicative of how these prints triggered a more dynamic relationship between his painting and printmaking. As Richard H. Axsom points out in his essay 'Frank Stella at Bedford', Stella's work with intaglio and relief printing was another exchange between media, which grew out of his tireless brushing, etching, wiping and painting of the magnesium skins he used for the metal-relief paintings.[3] Moreover, the way in which the *Swan Engraving* plates were inked and wiped defied conventional expectations. The impressive tonal variety of the prints was not built into the plates; rather, it was achieved through complex and time-consuming wiping techniques, with each

plate taking half a day to ink. However, such sophisticated procedures would not have borne fruit were it not for the thick cotton-fibre paper, handmade at Tyler Graphics, which was a crucial factor in the success of Stella's printmaking. On conventional mould-made paper, most of the ink would simply not have taken. This innovative and questioning approach to all aspects of the printmaking process resulted in densely textured surfaces that departed radically from traditional expectations.

It was the intense materiality and tactile appearance of the *Circuits* prints and the *Swan Engravings* that signalled their importance for Stella's subsequent work and for contemporary printmaking in general. He had finally found a way of making prints that were about the printmaking process itself. Tyler has described his collaboration with Stella as one that pushed him and the craft of printmaking to new limits, often referring to Stella's work as his 'prize exhibit'. Crucially for Stella, the *Circuit* prints and the *Swan Engravings* introduced an exchange of ideas between his artistic disciplines that had not existed before, a situation that had troubled and frustrated him. In 1983, Axsom quoted the artist as saying: 'What I like in the paintings I try to get into the prints. And then, what I like in the prints I try to get into the paintings. It works both ways.'[4] HD

1 Frank Stella, 'Melrose Avenue', in *Frank Stella at Tyler Graphics*, exh. cat., Walker Art Center, Minneapolis 1997, p.34.
2 Ibid.
3 Richard H. Axsom, 'Frank Stella at Bedford', in *Tyler Graphics: The Extended Image*, New York 1987, p.171.
4 Richard H. Axsom, *The Prints of Frank Stella: a Catalogue Raisonné, 1967–1982*, New York 1983, p.27.

Frank Stella (b.1936)

Stella was born in Malden, Massachusetts in 1936. He studied at Princeton University between 1954 and 1958. His early abstract geometric paintings positioned Stella as a major figure in the Minimalist movement; he participated in several group shows that defined this period including *Geometric Abstraction* at the Whitney Museum of American Art (1962) and *Toward a New Abstraction* at the Jewish Museum, New York (1963). His solo shows have included two retrospectives at the Museum of Modern Art, New York (1970 and 1987) as well as more recent exhibitions at the Museo Nacional Centro de Arte Reina Sofía, Madrid (1995) and the Museum of Contemporary Art, Miami (2000). He lives and works in New York City.

56 Iffish

IMAGINARY PLACES III
P12329–P12334 (incomplete)

1998
lithograph, screenprint, etching, aquatint,
relief and engraving on paper
556 × 536 mm
P12333

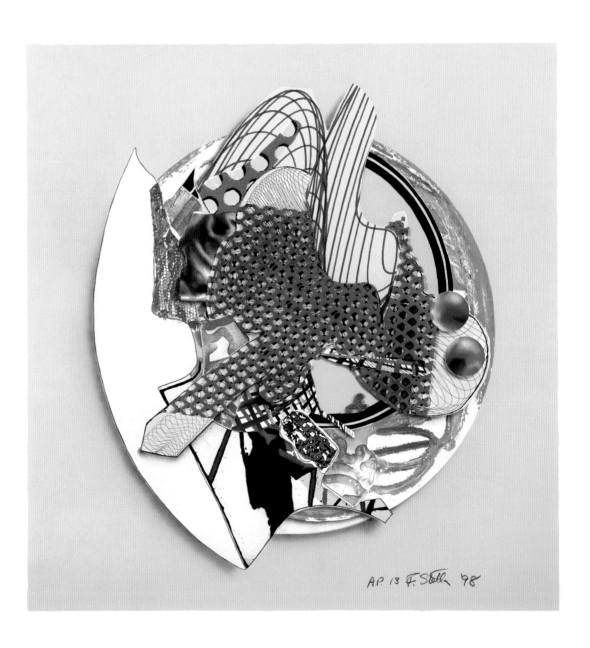

57 Roncador

IMAGINARY PLACES III

P12329–P12334 (incomplete)

1998
lithograph, screenprint, etching and relief on paper
542 × 554 mm
P12331

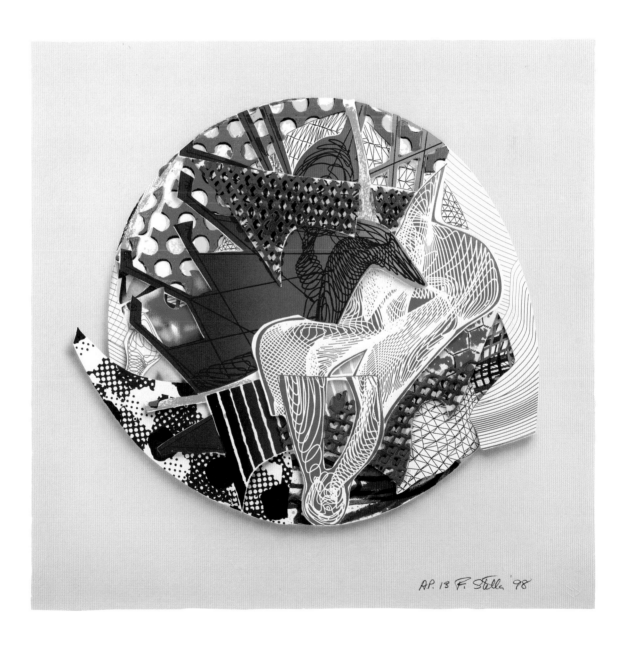

58 Schwarze Weisheit #1

2000
Aquatint and lithograph on paper
845 × 621 mm
P12321

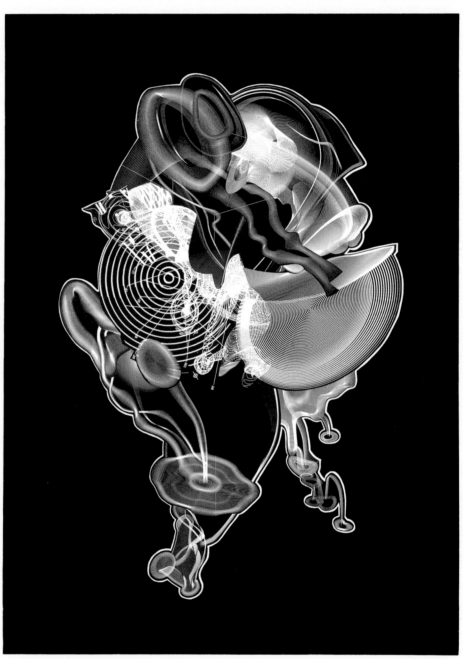

A.P. 6 F. Stella '00

59 Schwarze Weisheit #2

2000
Aquatint and lithograph on paper
811 × 629 mm
P12322

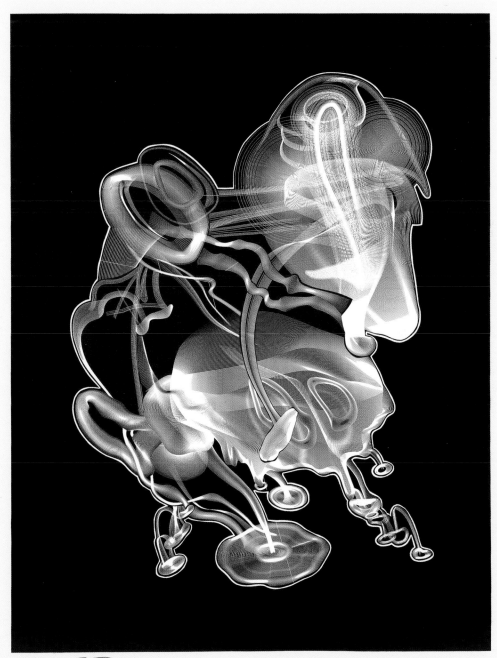

A.P. 6 F. Stella '00

60 Red Roofs, North Island, New Zealand

1990
drypoint and watercolour on paper
686 × 946 mm
P12372

Altoon Sultan (b.1948)

Sultan was born in Brooklyn, New York in
1948. She studied at Brooklyn College,
where she received a Bachelor of Fine Arts
degree in 1969 and a Master of Fine Arts
degree in 1971. Her work is included in the
permanent collection of major institutions
including the Metropolitan Museum of
Art, New York; the Museum of Fine Arts,
Boston and the Walker Art Center,
Minneapolis. Her solo exhibitions include
Marlborough Gallery, New York (1993,
1995, 1998) and Tibor de Nagy Gallery,
New York (2001). In 1995 she was elected
a member of the National Academy of
Design, New York. She currently lives and
works in Vermont.

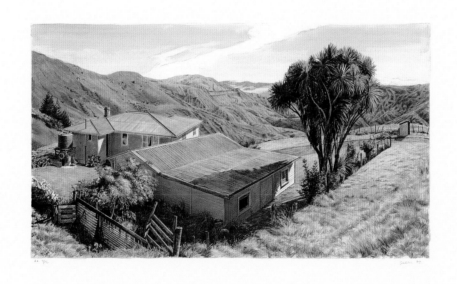

61 Black Eggs and Roses May 22 2000

2000
relief and woodcut on paper
1727 × 1753 mm
P12378

Donald Sultan makes paintings, drawings and prints that depict a range of everyday objects. He works in series and has focused in particular on images of lemons and other fruit, eggs, flowers, buttons, eightballs, dice and dominoes. His works are figurative in the sense that the objects depicted are almost always recognisable. He nevertheless considers himself to be an abstract artist, albeit one whose aim is to take a fresh approach to the abstract tradition by re-introducing figurative references.

Sultan often deliberately undercuts the readability of his images by playing with distinctions between figure and ground. In *Black Eggs and Roses May 22 2000*, for example, he sets three black oval shapes against a brightly coloured background. The roses of the title are heavily abstracted and are reduced to a pattern of red spots against a green ground. The black shapes initially read as voids, but the title indicates that they are in fact depictions of eggs. Even in his more realistically rendered works such as those from *The Album Series* 1996 (which depict a selection of objects from a variety of perspectives) Sultan eliminates minor details to give the objects a stylised feel.

In *Orange Feb 27* 1996, for example, the orange is shown from the front, bottom and side, but always as a perfect circle – any bumps or irregularities have been stripped away.

Sultan also plays with the boundaries between figuration and abstraction by enlarging and cropping the shapes so that they fill the picture space and come to resemble abstract forms. For his series of *Flowers* woodcuts made in 1999, he covers the page with oversized blooms reminiscent of Andy Warhol's large *Flower Paintings* of the mid-1960s. Sultan's flowers are stripped of nearly all their detail, and appear to float over a blank background. His work *Black Flowers Sept 26* 1999 is one of the most dramatic of this type. A single black flower fills the centre of the composition, its shape pierced in the centre by a white circle. At the edges of the page, black shapes suggest additional flowers hovering beyond the borders of the image. The white areas of background between the enlarged flowers, as well as the white aperture in the central flower, operate visually both as backdrop to the black shapes and as autonomous figures in themselves. K R

Donald Sultan (b.1951)

Sultan was born in Asheville, North Carolina in 1951. He received a Bachelor of Fine Arts degree from the University of North Carolina, Chapel Hill in 1973 and a Master of Fine Arts degree from the School of the Art Institute of Chicago in 1975. His work is included in the permanent collections of major institutions including the Metropolitan Museum of Art, the Solomon R. Guggenheim Museum of Art, the Whitney Museum of American Art and the Museum of Modern Art, New York. His solo exhibitions have included the American Federation of the Arts, New York (1992), the Jewish Museum, New York (1999) and the Memphis Brooks Museum of Art (2000).

DONALD SULTAN

62 Button March 1 1996

THE ALBUM SERIES
P12379–P12382 (incomplete)

1996
lithograph, woodcut and etching on paper
1073 × 743 mm
P12381

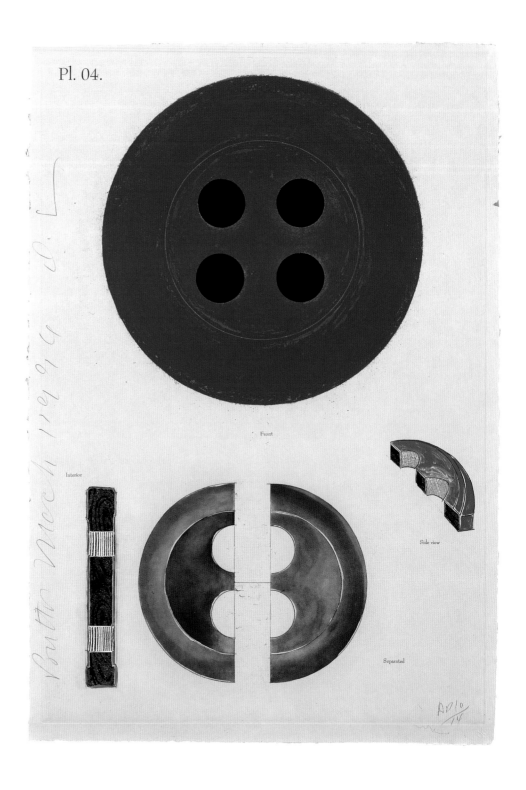

DONALD SULTAN

63 Orange Feb 27 1996

THE ALBUM SERIES
P12379–P12382 (incomplete)

1996
lithograph, woodcut and etching on paper
1073 × 743 mm
P12380

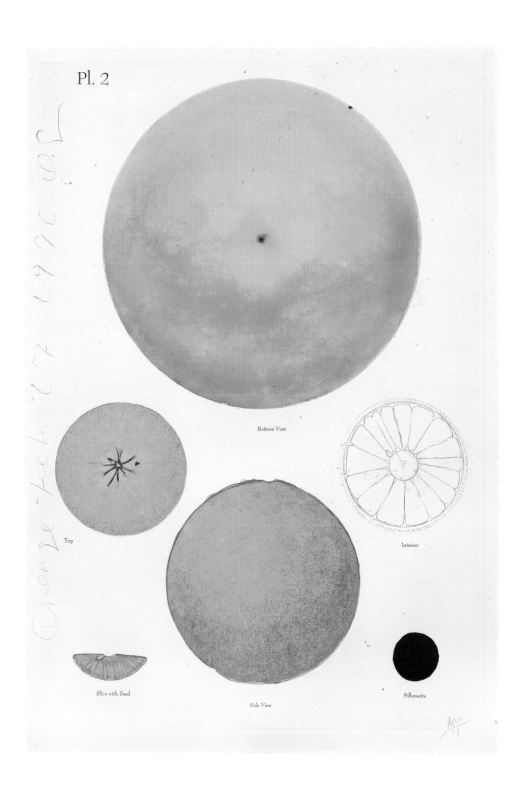

MASAMI TERAOKA

64 Catfish Envy

1993
woodcut, etching, aquatint and paint on paper
680 × 978 mm
P12385

Masami Teraoka (b.1936)

Teraoka was born in 1936 in Onomichi, Japan.
He studied at Kwansei Gakuin University
between 1954 and 1959 and at the Otis Art
Institute from 1964 to 1968. His solo shows
have included the Hammond Museum,
North Salem, New York (1998), San Diego
State University (2001) and McKinney
Avenue Contemporary, Dallas (2004).
His work is included in the permanent
collection of major institutions including the
Los Angeles County Museum of Art, the
Walker Art Center, Minneaopolis and the
National Gallery of Victoria, Melbourne.
He currently lives and works in Hawaii.

65 KTL#1

1982
lithograph on paper
699 × 699 mm
P12387

Jack Tworkov (1900–1982)

Tworkov was born in Biala, Poland in 1900.
He moved in 1913 to New York where he
lived until his death in Provincetown,
Massachusetts in 1982. He studied at
Columbia University from 1920 and 1923,
at the National Academy of Design from
1923 to 1925 and at the Art Students
League from 1925 to 1926. His solo
exhibitions included shows at the Whitney
Museum of American Art (1964 and 1971)
and the Solomon R. Guggenheim Museum
(1982) and a major retrospective at the
Philadelphia Academy of Fine Arts (1987).
He received the John Simon Guggenheim
Memorial Foundation Fellowship in 1970
and was elected a member of the
American Academy and Institute of Arts
and Letters in 1981.

66 Sheep Skull II

1998
etching and aquatint on paper
419 × 648 mm
P12397

John Walker's portfolio of prints *Passing Bells* 1998 takes its title from the poem *Anthem for Doomed Youth* by the English poet Wilfred Owen (1893–1918). Written in 1917 about the horrors of World War I, the poem opens with the lines:

What passing-bells for these who die as cattle?
Only the monstrous anger of the guns.
Only the stuttering rifles' rapid rattle
Can patter out their hasty orisons.

Walker chose the title because, as he has explained, the poem 'sounded just like my father talking. The poetry makes me feel – because of the shared experience – very close to my father.'[1] The portfolio of twenty-seven intaglio prints was inspired by his father's matter-of-fact accounts of his experiences both on the battle-field during World War I and in Birmingham on his return from battle. Eleven members of Walker's family died in the Battle of Somme in 1916, one of the bloodiest conflicts of the war. His father was injured at Somme and again in 1917 at Passchendaele in the third battle of Ypres.

The prints primarily feature etching and aquatint and some also include drypoint and engraving. All were printed on handmade paper made at the Mount Kisco workshop. In those prints made using only etching, Walker has employed the medium to create stark, sketch-like images of a wounded soldier with a bandaged head. This figure appears in a variety of poses, often with amputated legs. In one particularly harrowing image (number 9 in the series) the soldier is shown slumped against a tree, his body half torn apart. Walker's prints have often been compared to Goya's etchings, and this one depicting a mutilated soldier resting against a tree is particularly reminiscent of images from Goya's series *The Disasters of War* (1814). The prints in the *Passing Bells* portfolio that incorporate both etching and aquatint are much darker and more sombre in tone than the straight etchings. The porous ground used in aquatint creates a dark mist that surrounds the figures like a pall. All of the prints in the portfolio share an aggressive, expressionistic style that amplifies the brutality of the scenes depicted.

A second figure, with a sheep-skull head, recurs in several of the prints. The figure represents Walker's father, and the significance of the sheep's skull resonates on several different levels. There are obvious religious overtones – Walker makes a connection between soldiers marching into battle and the symbol of the sacrificial lamb. Moreover, in an echo of Owen's poem, the soldiers saw themselves as animals being led to slaughter; reports from the battlefields at Verdun told of soldiers bleating like sheep as they were led into battle.[2] Walker has also spoken of the sheep-skull symbol in relation to his father's stories of soldiers playing football with skulls found on the battle-fields. The final print in the portfolio brings together three generations, placing further emphasis on the very personal significance of Walker's iconography. Alongside the sheep-skull character is a horned figure who is said to repre-sent Walker's own son, and a self-portrait in the form of a second sheep-skull-headed figure shown painting at an easel. K R

1 Quoted in 'Sons and Fathers', www.nga.gov.au/exhibitions/unisonsfathers.htm
2 John R. Stromberg, *Theatre of Recollection: Paintings and Prints by John Walker*, exh. cat., Boston University Art Gallery, Boston 1998, p.27.

a/p viii Waltu 95

67 The Witness

1999
etching, aquatint and paint on paper
559 × 406 mm
P12388

68 Mount Kisco Studio

1996
woodcut on paper
927 × 775 mm
P12393

John Walker (b.1939)

Walker was born in Birmingham in 1939.
He studied at Birmingham College of Art
from 1955 to 1960 and at the Academie
de la Grande Chaumiere, Paris from 1961
to 1963. He was awarded first prize at the
John Moores Exhibition, Liverpool in 1976
and received a Guggenheim Fellowship in
1981. His recent solo exhibitions include the
Santa Barbara Contemporary Arts Forum
(1997), the Yale Center for British Art,
New Haven (1999) and the Nielsen Gallery,
Boston (2001). His work is represented
in the permanent collections of major
institutions including the British Museum;
the Metropolitan Museum of Art, New York;
the Museum of Modern Art, New York
and the Art Gallery of New South Wales,
Sydney. He currently lives in New York.

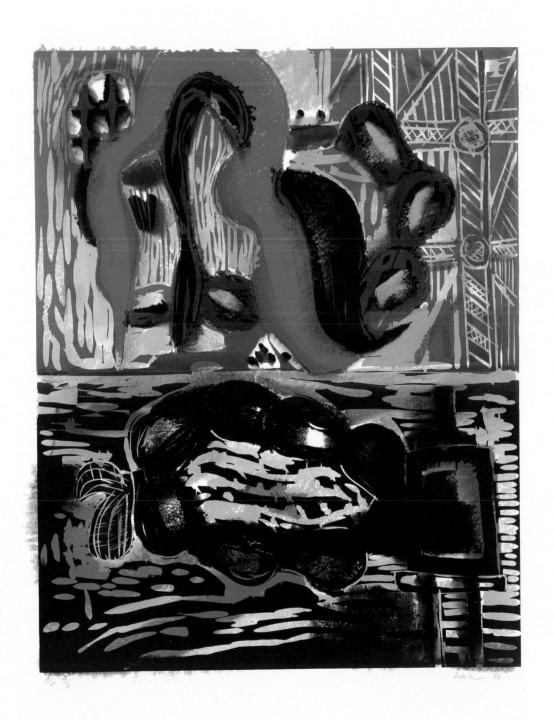

69 Double Geese Mountain

1981
screenprint, lithograph and stencil on paper
692 × 572 mm
P12438

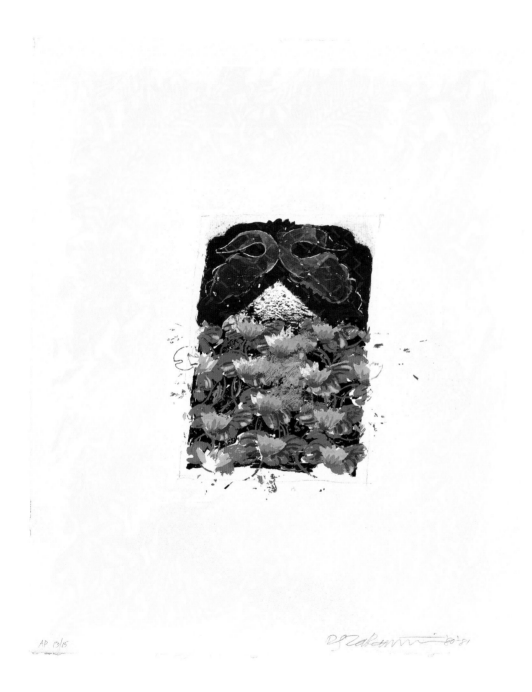

AP 13/15

Robert Rahway Zakanitch (b.1935)

Zakanitch was born in 1935 in Elizabeth, New Jersey. Between 1954 and 1958 he studied at the Cooper Union, New York and the Newark School of Fine and Industrial Art. His work is included in the permanent collections of major institutions including the Whitney Museum of American Art, New York; the Ludwig Collection, Aachen and the Hirshhorn Museum and Sculpture Garden, Washington, D.C. In 1995 he received a John Simon Guggenheim Foundation Grant. His solo shows have included the Daniel Templon Gallery, Paris (1991), the University of Iowa Museum of Art (1995), Marion Locks Gallery, Philadelphia (1997) and Patricia Faure Gallery, Los Angeles (1997). He lives and works in New York City.

The Kenneth E. Tyler Gift

Complete list of works

All works are Tate, Presented by Tyler Graphics Ltd in honour of Pat Gilmour, Tate Print Department 1974–7, 2004
Dimensions are given in millimetres, height before width, and refer to the size of the image.

Ed Baynard

PORTFOLIO TITLE
My Egypt, P11984–P11991 (incomplete)

My Egypt 1997
Lithograph on paper
728 × 880 mm
P11984

Little Sister 1997
Lithograph on paper
980 × 567 mm
P11985

Mount Kisco Arabesque 1997
Lithograph on paper
1005 × 685
P11986

Sunday Morning 1997
Lithograph on paper
993 × 692 mm
P11987

Manhattan at Dusk 1997
Lithograph on paper
992 × 690 mm
P11988

Cool Moon 1997
Lithograph on paper
1005 × 694 mm
P11989

Venice Looking East 1997
Lithograph on paper
993 × 674 mm
P11990

Downtown Jubilee 1997
Lithograph on paper
715 × 877 mm
P11991

PORTFOLIO TITLE
The London Quartet
P11992–P11994 (incomplete)

Westbourne Grove 1988
Lithograph, aquatint and woodcut on paper
616 × 611 mm
P11992

Pembridge Gardens 1988
Lithograph, aquatint and woodcut on paper
611 × 578 mm
P11993

Notting Hill Gate 1988
Lithograph, aquatint and woodcut on paper
660 × 590 mm
P11994

The Tulip Pitcher 1980
Woodcut on paper
823 × 762 mm
P11995

A Dark Pot with Roses 1980
Woodcut on paper
1027 × 490 mm
P11996

Monotype (B-2) 1981
Monotype on paper
865 × 590 mm
P11997

Per Inge Bjørlo

PORTFOLIO TITLE
Heads from Balance
P11998–P12012 (incomplete)

Head I 1998
Drypoint on paper
282 × 230 mm
P11998

Head II 1998
Drypoint on paper
282 × 229 mm
P11999

Head III 1998
Drypoint on paper
283 × 229 mm
P12000

Head IV 1998
Drypoint on paper
228 × 282 mm
P12001

Head V 1998
Drypoint and aquatint on paper
282 × 227 mm
P12002

Head VI 1998
Drypoint, aquatint and etching on paper
282 × 229 mm
P12003

Head VII 1998
Drypoint and aquatint on paper
227 × 283 mm
P12004

Head VIII 1998
Drypoint and aquatint on paper
223 × 282 mm
P12005

Head IX 1998
Drypoint on paper
225 × 281 mm
P12006

Head X 1998
Drypoint and aquatint on paper
226 × 282 mm
P12007

Head XI 1998
Drypoint and aquatint on paper
226 × 283 mm
P12008

Head XII 1998
Drypoint and aquatint on paper
282 × 227 mm
P12009

Head XIII 1998
Drypoint and aquatint on paper
227 × 285 mm
P12010

Head XIV 1998
Drypoint and aquatint on paper
282 × 226 mm
P12011

Head XV 1998
Drypoint on paper
282 × 226 mm
P12012

Sort 1998
Aquatint and drypoint on paper
403 × 494 mm
P12013

Let In 1998
Aquatint and drypoint on paper
403 × 494 mm
P12014

Silence: Flight, Dive, Moonshine 1999
Linocut on paper
923 × 1458 mm
P12015

Atmosphere I 1999
Linocut on paper
803 × 968 mm
P12016

Atmosphere II 1999
Linocut on paper
803 × 1034 mm
P12017

Couple 1999
Linocut on paper
1004 × 1007 mm
P12018

Dark Relief 1999
Linocut on paper
834 × 702 mm
P12019

Line 1999
Linocut on paper
754 × 669 mm
P12020

Claw 1999
Linocut on paper
754 × 670 mm
P12021

Mind 1999
Linocut on paper
673 × 754 mm
P12022

Listening Flesh 1999
Linocut on paper
455 × 438 mm
P12023

Listening Water 1999
Linocut on paper
454 × 438 mm
P12024

Listening Earth 1999
Linocut on paper
455 × 438 mm
P12025

Behind 1996
Lithograph on paper
970 × 660 mm
P12026

Drifting 1996
Linocut and lithograph on paper
615 × 608 mm
P12027

Inside 1996
Lithograph on paper
905 × 710 mm
P12028

Pressure 1996
Linocut and lithograph on paper
778 × 1183 mm
P12029

Trust 1996
Linocut and lithograph on paper
775 × 800 mm
P12030

Drift 1996
Linocut and lithograph on paper
695 × 1020 mm
P12031

Stanley Boxer

PORTFOLIO TITLE
Carnival of Animals
P12032–P12042 (incomplete)

Introduction, Royal Prance of the Lion 1979
Etching and engraving on paper
495 × 542 mm
P12032

Chicken and Cock 1979
Etching, engraving and drypoint on paper
489 × 510 mm
P12033

Jackass Free 1979
Etching, engraving and drypoint on paper
553 × 590 mm
P12034

Turtle 1979
Etching, aquatint, engraving and drypoint on paper
566 × 468 mm
P12035

Kangaroos 1979
Etching, aquatint and engraving on paper
522 × 566 mm
P12036

Aquarium 1979
Etching, aquatint and engraving on paper
549 × 580 mm
P12037

Personages with Long Ears 1979
Etching, aquatint and engraving on paper
529 × 583 mm
P12038

Cockatoo in the Depth of the Woods 1979
Etching, aquatint and engraving on paper
526 × 577 mm
P12039

Birds Soaring 1979
Etching, aquatint and engraving on paper
535 × 590 mm
P12040

Pianist 1979
Etching, aquatint, engraving and drypoint on paper
515 × 565 mm
P12041

Finale 1979
Etching, aquatint, engraving and drypoint on paper
490 × 505 mm
P12042

PORTFOLIO TITLE
Ring of Dust in Bloom
P12043–P12054 (incomplete)

Conventionofslydiscussants 1976
Etching, aquatint and watercolour on paper
352 × 155 mm
P12043

Askanceglancelongingly 1976
Etching, aquatint and watercolour on paper
315 × 283 mm
P12044

Curiousstalking 1976
Etching, aquatint and watercolour on paper
153 × 456 mm
P12045

Pauseofnoconcern 1976
Etching, aquatint and watercolour on paper
281 × 378 mm
P12046

Strangetalkwithfriend 1976
Etching, aquatint and watercolour on paper
260 × 263 mm
P12047

Oddconversationatnoon 1976
Etching, aquatint and watercolour on paper
283 × 353 mm
P12048

Amissinamist 1976
Etching, aquatint and watercolour on paper
276 × 447 mm
P12049

Argumentofnoavail 1976
Etching, aquatint and watercolour on paper
313 × 302 mm
P12050

Buddingwithoutpast 1976
Etching, aquatint and watercolour on paper
302 × 408 mm
P12051

Feybowlofplay 1976
Etching, aquatint and watercolour on paper
203 × 380 mm
P12052

Gatheringforsomereason 1976
Etching, aquatint and watercolour on paper
331 × 360 mm
P12053

Obliquequestionofaturtle 1976
Etching, aquatint and watercolour on paper
371 × 251 mm
P12054

Cleavedsummerautumnalglance 1977
Etching, aquatint and engraving on paper
371 × 596 mm
P12055

Softwinterseekingwhiteness 1976
Lithograph on paper
327 × 275 mm
P12056

Anthony Caro

Untitled 1982
Paper and paint
927 × 565 × 133 mm
T11797

Dusty 1993
Paper and paint
280 × 355 × 350 mm
T11798

Untitled 1982
Paper and paint
470 × 597 × 178 mm
T11800

Point 1993
Paper and paint
230 × 460 × 440 mm
T11801

William Crutchfield

The Voyage 2000
Lithograph on paper
530 × 975 mm
P12062

Trestle Trains 1978
Lithograph on paper
940 × 1353 mm
P12063

Elevated Smoke 1978
Lithograph on paper
925 × 1292 mm
P12064

Burial at Sea 1978
Lithograph on paper
945 × 1295 mm
P12065

Diamond at Sea 1978
Lithograph on paper
925 × 1255 mm
P12066

Cubie Smoke 1978
Lithograph on paper
940 × 1200 mm
P12067

Mark di Suvero

Tetra 1976
Lithograph on paper
1152 × 843 mm
P12068

Helen Frankenthaler

Mirabelle 1990
Lithograph on paper
764 × 942 mm
P12069

PORTFOLIO TITLE
Magellan Series
P12070–P12076 (complete)

Magellan I 2001
Etching, aquatint and drypoint
on paper
328 × 480 mm
P12070

Magellan II 2001
Etching and drypoint on paper
327 × 429 mm
P12071

Magellan III 2001
Etching, aquatint and drypoint
on paper
178 × 481 mm
P12072

Magellan IV 2001
Etching, aquatint and drypoint
on paper
565 × 762 mm
P12073

Magellan V 2001
Etching, aquatint and drypoint
on paper
251 × 480 mm
P12074

Magellan VI 2001
Etching and drypoint on paper
177 × 480 mm
P12075

Magellan VII 2001
Etching, aquatint and drypoint
on paper
352 × 480 mm
P12076

Round Robin 2000
Etching, aquatint and mezzotint
on paper
177 × 421 mm
P12077

Making Music 2000
Etching, aquatint and mezzotint
on paper
408 × 633 mm
P12078

A Page From A Book I 1997
Etching, aquatint, mezzotint
and stencil on paper
257 × 629 mm
P12079

A Page From A Book II 1997
Etching and aquatint on paper
142 × 456 mm
P12080

A Page From A Book III 1997
Etching, aquatint, mezzotint
and stencil on paper
257 × 629 mm
P12081

Reflections I 1995
Lithograph on paper
401 × 502 mm
P12082

Reflections II 1995
Lithograph on paper
531 × 398 mm
P12083

Reflections III 1995
Lithograph on paper
369 × 504 mm
P12084

Reflections IV 1995
Lithograph on paper
534 × 369 mm
P12085

Reflections VI 1995
Lithograph on paper
428 × 337 mm
P12086

Reflections VII 1995
Lithograph on paper
291 × 402 mm
P12087

Reflections VIII 1995
Lithograph on paper
402 × 300 mm
P12088

Reflections IX 1995
Lithograph on paper
504 × 372 mm
P12089

Reflections X 1995
Lithograph on paper
376 × 300 mm
P12090

All About Blue 1994
Lithograph and woodcut
on paper
1232 × 734 mm
P12091

Madame de Pompadour 1990
Lithograph on paper
1106 × 750 mm
P12092

Flirting with Stone 1990
Lithograph on paper
935 × 687 mm
P12093

Day One 1987
Aquatint, etching and drypoint
on paper
413 × 413 mm
P12094

PORTFOLIO TITLE
This Is Not A Book
P12095–P12103 (complete)

[no title] 1997
Etching on paper
276 × 660 mm
P12095

[no title] 1997
Etching on paper
276 × 660 mm
P12096

[no title] 1997
Etching on paper
276 × 660 mm
P12097

[no title] 1997
Etching on paper
276 × 660 mm
P12098

[no title] 1997
Etching on paper
276 × 660 mm
P12099

[no title] 1997
Etching on paper
276 × 660 mm
P12100

[no title] 1997
Etching on paper
276 × 660 mm
P12101

[no title] 1997
Etching on paper
276 × 660 mm
P12102

[no title] 1997
Etching on paper
276 × 660 mm
P12103

Richard Hamilton

Sunset 1976
Lithograph on paper
239 × 358 mm
P12104

*Flower-Piece B,
Cyan Separation* 1976
Lithograph on paper
432 × 314 mm
P12105

Flower-Piece B 1976
Lithograph on paper
465 × 291 mm
P12106

*Flower-Piece B,
Crayon Study* 1976
Lithograph on paper
465 × 318 mm
P12107

Michael Heizer

Levitated Mass 1983
Lithograph, screenprint and
etching on paper
791 × 1142 mm
P12108

Dragged Mass 1983
Lithograph, screenprint and
etching on paper
701 × 1182 mm
P12109

Circle II 1977
Etching and aquatint on paper
601 × 602 mm
P12110

Al Held

Prime Moments I 1999
Screenprint and paint on paper
232 × 866 mm
P12111

Prime Moments II 1999
Screenprint and paint on paper
529 × 783 mm
P12112

Prime Moments III 1999
Lithograph, screenprint, etching,
aquatint and paint on paper
667 × 925 mm
P12113

Prime Moments IV 1999
Lithograph, screenprint, etching,
aquatint and paint on paper
602 × 1273 mm
P12114

Prime Moments V 1999
Lithograph, screenprint and
paint on paper
750 × 1071 mm
P12115

David Hockney

Pool II-D 2000
Lithograph on paper
544 × 739 mm
P12116

*The New and the Old and
the New* 1991
Lithograph on paper
757 × 1075 mm
P12455

Rampant 1991
Lithograph on paper
762 × 1073 mm
P12456

[no title]
Lithograph on paper
737 × 991 mm
P12457

[no title]
Lithograph on paper
1232 × 908 mm
P12459

[no title]
Lithograph on paper
1232 × 908 mm
P12460

[no title]
Lithograph on paper
1232 × 908 mm
P12461

Ellsworth Kelly

Saint Martin Landscape 1979
Lithograph, screenprint and
collage on paper
388 × 557 mm
P12117

*Saint Martin Landscape,
State I-A* 1979
Lithograph and screenprint
on paper
388 × 557 mm
P12118

Terence La Noue

Red Mist Rising 1994
Mezzotint, aquatint, woodcut
and collage on paper
851 × 1334 mm
P12119

Search for Atlantis 1991
Etching, aquatint, lithograph
and collage on paper
1099 × 1321 mm
P12120

The Sorcerer's Apprentice 1982
Mezzotint, woodcut, etching,
aquatint, collage and paint
on paper
1245 × 1035 mm
P12121

PORTFOLIO TITLE
The Ritual Series
P12122–P12126 (incomplete)

The Dream of Gods 1987
Lithograph, woodcut and
collage on paper
1121 × 1245 mm
P12122

Papuan Gulf 1987
Etching, aquatint, lithograph,
woodcut, engraving, drypoint
and collage on paper
914 × 1003 mm
P12123

The Fossil Garden 1987
Etching, aquatint, lithograph,
woodcut, engraving, drypoint
and collage on paper
914 × 1003 mm
P12124

The Talking Drums 1987
Etching, aquatint, woodcut,
dryppoint, collage and paint
on paper
914 × 1003 mm
P12125

The Water Spirits 1987
Etching, aquatint, lithograph,
woodcut, engraving, drypoint
and collage on paper
914 × 1003 mm
P12126

Roy Lichtenstein

Reflections on Hair 1990
Lithograph, screenprint,
woodcut, collage and
embossing on paper
311 × 1143 mm
P12127

Reflections on Brushstrokes 1990
Lithograph, screenprint,
woodcut, collage and
embossing on paper
1460 × 1803 mm
P12128

American Indian Theme IV 1980
Woodcut and lithograph
on paper
724 × 712 mm
P12129

Joan Mitchell

PORTFOLIO TITLE
Poems
P12130–P12137 (complete)

Joie de Vivre 1992
Lithograph on paper
385 × 295 mm
P12130

In Time 1992
Lithograph on paper
425 × 352 mm
P12131

Morning 1992
Lithograph on paper
445 × 310 mm
P12132

Cobble Hill 1992
Lithograph on paper
445 × 665 mm
P12133

Mornings on the Bridge 1992
Lithograph on paper
435 × 670 mm
P12134

Sky 1992
Lithograph on paper
393 × 310 mm
P12135

Urn Burial 1992
Lithograph on paper
415 × 337 mm
P12136

Avenue of Poplars 1992
Lithograph on paper
419 × 331 mm
P12137

PORTFOLIO TITLE
Sunflowers Series
P12138–P12139 (incomplete)

Sunflowers III 1992
Lithograph on paper
1328 × 2069 mm
P12138

Sunflowers IV 1992
Lithograph on paper
1390 × 2057 mm
P12139

PORTFOLIO TITLE
Trees Series
P12140–P12143 (incomplete)

Trees I 1992
Lithograph on paper
1305 × 1950 mm
P12140

Trees II 1992
Lithograph on paper
1270 × 1967 mm
P12141

Trees III 1992
Lithograph on paper
1365 × 2004 mm
P12142

Trees IV 1992
Lithograph on paper
1300 × 2005 mm
P12143

Bedford II 1981
Lithograph on paper
1017 × 757 mm
P12144

Flower II 1981
Lithograph on paper
1000 × 735 mm
P12145

Flower III 1981
Lithograph on paper
985 × 755 mm
P12146

Sides of a River I 1981
Lithograph on paper
998 × 712 mm
P12147

Sides of a River II 1981
Lithograph on paper
1013 × 750 mm
P12148

Sides of a River III 1981
Lithograph on paper
970 × 745 mm
P12149

Brush 1981
Lithograph on paper
965 × 740 mm
P12150

Brush, State I 1981
Lithograph on paper
967 × 730 mm
P12151

Malcolm Morley

Beach Scene with Parasailor 1998
Lithograph on paper
877 × 1163 mm
P12152

Pamela Running Before the Wind with a Dutch Lighthouse 1998
Lithograph on paper
1263 × 872 mm
P12153

Flying Cloud with Montgolfiére Balloon 1998
Lithograph on paper
835 × 1092 mm
P12154

Devonshire Cows 1982
Lithograph on paper
1108 × 804 mm
P12155

Devonshire Bullocks 1982
Lithograph on paper
1211 × 891 mm
P12156

Horses 1982
Lithograph on paper
984 × 706 mm
P12157

Goats in the Shed 1982
Lithograph on paper
712 × 1005 mm
P12158

Goat 1982
Lithograph on paper
799 × 1029 mm
P12159

Fish 1982
Lithograph on paper
648 × 991 mm
P12160

Robert Motherwell

Game of Chance 1987
Lithograph, aquatint, collage and paint on paper
876 × 699 mm
P12161

Vivo (Sepia) 1986
Lithograph on paper
865 × 1093 mm
P12162

Black Rumble 1984
Lithograph on paper
816 × 660 mm
P12163

America-La France Variations II 1984
Lithograph and collage on paper
1156 × 737 mm
P12164

America-La France Variations III 1984
Lithograph and collage on paper
1219 × 781 mm
P12165

America-La France Variations IV 1984
Lithograph and collage on paper
1181 × 816 mm
P12166

America-La France Variations V 1984
Lithograph and collage on paper
1168 × 800 mm
P12167

America-La France Variations VI 1984
Lithograph and collage on paper
1168 × 800 mm
P12168

America-La France Variations VII 1984
Lithograph and collage on paper
1340 × 914 mm
P12169

America-La France Variations IX 1984
Lithograph and collage on paper
724 × 552 mm
P12170

PORTFOLIO TITLE
El Negro
P12171–P12189 (complete)

Negro 1983
Lithograph on paper
334 × 317 mm
P12171

Mourning 1983
Lithograph on paper
340 × 350 mm
P12172

Night Arrived 1983
Lithograph on paper
180 × 238 mm
P12173

Elegy Black Black 1983
Lithograph on paper
383 × 970 mm
P12174

Black Banners 1983
Lithograph on paper
277 × 220 mm
P12175

Black of the Echo 1983
Lithograph on paper
231 × 339 mm
P12176

Eternal Black 1983
Lithograph on paper
328 × 245 mm
P12177

Black Wall of Spain 1983
Lithograph on paper
350 × 905 mm
P12178

Airless Black 1983
Lithograph on paper
350 × 450 mm
P12179

Black Concentrated 1983
Lithograph on paper
280 × 490 mm
P12180

Black in Black 1983
Lithograph on paper
281 × 213 mm
P12181

Forever Black 1983
Lithograph on paper
388 × 910 mm
P12182

Invisible Stab 1983
Lithograph on paper
315 × 305 mm
P12183

Black Lament 1983
Lithograph on paper
340 × 622 mm
P12184

Black with No Way Out 1983
Lithograph on paper
390 × 917 mm
P12185

Gypsy Curse 1983
Lithograph on paper
227 × 148 mm
P12186

Black Undone by Tears 1983
Lithograph on paper
263 × 297 mm
P12187

Through Black Emerge Purified 1983
Lithograph on paper
305 × 825 mm
P12188

Poor Spain 1983
Lithograph on paper
349 × 885 mm
P12189

Through Black Emerge Purified 1983
Lithograph on paper
310 × 830 mm
P12190

Airless Black 1983
Lithograph on paper
340 × 462 mm
P12191

Black Wall of Spain 1983
Lithograph on paper
350 × 916 mm
P12192

On Stage 1983
Lithograph on paper
334 × 356 mm
P12193

The Quarrel 1983
Lithograph on paper
910 × 650 mm
P12194

The Dalton Print 1979
Lithograph on paper
550 × 455 mm
P12195

La Guerra I 1980
Lithograph on paper
755 × 1108 mm
P12196

La Guerra II 1980
Lithograph on paper
704 × 997 mm
P12197

Brushstroke 1980
Lithograph on paper
399 × 295 mm
P12198

El General 1980
Lithograph on paper
994 × 698 mm
P12199

Easter Day 1979 1980
Lithograph on paper
875 × 580 mm
P12200

Spanish Elegy I 1975
Lithograph on paper
360 × 475 mm
P12201

Spanish Elegy II 1975
Lithograph on paper
370 × 471 mm
P12202

Mediterranean 1975
Lithograph and screenprint on paper
722 × 509 mm
P12203

Mediterranean, State I White 1975
Lithograph and screenprint on paper
722 × 509 mm
P12204

Mediterranean, State II Yellow 1975
Lithograph and screenprint on paper
725 × 508 mm
P12205

John Newman

Second Thoughts I 1995
Linocut on paper
315 × 238 mm
P12206

Second Thoughts II 1995
Linocut on paper
308 × 231 mm
P12207

Second Thoughts III 1995
Linocut on paper
314 × 239 mm
P12208

Second Thoughts IV 1995
Linocut on paper
313 × 238 mm
P12209

Second Thoughts V 1995
Linocut on paper
314 × 238 mm
P12210

Second Thoughts VI 1995
Linocut on paper
315 × 237 mm
P12211

Making Ends Meet 1992
Lithograph on paper
678 × 518 mm
P12212

Loop Hole 1993
Etching, aquatint, mezzotint and engraving on paper
409 × 275 mm
P12213

Jaw Breaker 1992
Lithograph on paper
307 × 321 mm
P12214

Head Lock 1992
Lithograph on paper
668 × 537 mm
P12215

Auto-da-fé 1990
Lithograph, etching, aquatint, engraving and drypoint on paper
1414 × 1425 mm
P12216

Sotto voce 1990
Lithograph on paper
1437 × 1432 mm
P12217

Moving Target 1990
Lithograph on paper
1435 × 1425 mm
P12218

Color Double 1990
Lithograph on paper
430 × 322 mm
P12219

Twist in Turn 1990
Lithograph on paper
1062 × 936 mm
P12220

Twist in Time 1990
Etching, drypoint and aquatint on paper
555 × 470 mm
P12221

Afterimage (for Moving Target) 1990
Lithograph on paper
873 × 873 mm
P12222

Upward Turn (Study) 1995
Lithograph on paper
296 × 232 mm
P12223

Color Double 1990
Lithograph on paper
686 × 502 mm
P12458

Hugh O'Donnell

Waccabuc I 1992
Lithograph and paint on paper
1035 × 1346 mm
P12224

Sam Posey

Artist and Model 2000
Screenprint on paper
789 × 590 mm
P12225

Odyssey 2000
Screenprint on paper
786 × 663 mm
P12226

Good-bye Kisco Avenue 2001
Screenprint and woodcut
on paper
795 × 657 mm
P12227

James Rosenquist

Katonah Muse 1993
Lithograph on paper
681 × 500 mm
P12228

Magic Bowl 1992
Lithograph on paper
794 × 559 mm
P12229

The Light Bulb Shining 1992
Lithograph and metal on paper
1334 × 1061 mm
P12230

Time Dust 1992
Relief, lithograph, screenprint,
etching, collage and metal
on paper
2178 × 10668 mm
P12231

House of Fire 1989
Relief, lithograph and collage
on paper
1384 × 3042 mm
P12232

PORTFOLIO TITLE
Welcome to the Water Planet
P12233–P12241 (incomplete)

Space Dust 1989
Relief, lithograph and collage
on paper
1689 × 2673 mm
P12233

Time Door Time D'Or 1989
Relief, lithograph and collage
on paper
2477 × 3048 mm
P12234

*The Bird of Paradise Approaches
the Hot Water Planet* 1989
Relief, lithograph and collage
on paper
2464 × 2146 mm
P12235

Sky Hole 1989
Relief, lithograph and collage
on paper
2597 × 1486 mm
P12236

Where the Water Goes 1989
Relief, lithograph and collage
on paper
2610 × 1473 mm
P12237

Sun Sets on the Time Zone 1989
Relief, lithograph and collage
on paper
2019 × 1473 mm
P12238

Skull Snap 1989
Relief, lithograph and collage
on paper
1511 × 1511 mm
P12239

Skull Snap, State I 1989
Relief, lithograph and collage
on paper
1511 × 1511 mm
P12240

*Caught One Lost One for the Fast
Student or Star Catcher* 1989
Lithograph, relief and collage
on paper
1384 × 965 mm
P12241

Woman in the Sun 1991
Lithograph on paper
840 × 1080 mm
P12242

David Salle

PORTFOLIO TITLE
High and Low
P12243–P12247 (incomplete)

High and Low 1994
Lithograph, woodcut and
screenprint on paper
1445 × 1135 mm
P12243

Fast and Slow 1994
Lithograph and woodcut
on paper
1423 × 993 mm
P12244

High and Wide 1994
Lithograph and woodcut
on paper
1473 × 948 mm
P12245

Low and Narrow 1994
Lithograph, woodcut, etching
and collage on paper
953 × 1245 mm
P12246

Long and High 1994
Lithograph and woodcut
on paper
1260 × 782 mm
P12247

Alan Shields

Gas-Up 1984
Woodcut, etching, aquatint,
relief and collage on paper
1435 × 1029 mm
P12248

Odd-Job 1984
Woodcut, etching, relief
and collage on paper
1067 × 1067 mm
P12249

Bull-Pen 1984
Woodcut, etching, aquatint
and collage on paper
1022 × 1061 mm
P12250

Two Birds, Woodcock I 1978
Lithograph on paper
527 × 617 mm
P12251

Richard Smith

PORTFOLIO TITLE
Fields and Streams
P12252–P12258 (incomplete)

Ick 1982
Etching, aquatint and
lithograph on paper
511 × 444 mm
P12252

Pix 1982
Aquatint, lithograph and
drypoint on paper
480 × 390 mm
P12253

Pix, State I 1982
Aquatint and drypoint on paper
486 × 395 mm
P12254

Ouse 1982
Aquatint, etching and lithograph
on paper
576 × 575 mm
P12255

Cam 1982
Aquatint, etching and lithograph
on paper
517 × 575 mm
P12256

Double Meadow 1982
Aquatint, etching and lithograph
on paper
763 × 578 mm
P12257

Hiz 1982
Aquatint, etching and lithograph
on paper
685 × 540 mm
P12258

T.L. Solien

Excalibur 1986
Relief, woodcut and mezzotint
on paper
1066 × 412 mm
P12259

Psyche: The Blue Martin 1985
Woodcut, aquatint and etching
on paper
579 × 572 mm
P12260

Steven Sorman

from time to time – i 2000
Collage and paint on paper
1683 × 1257 mm
P12261

each way 1999
Etching, aquatint and engraving
on paper
1072 × 406 mm
P12262

change of heart 1999
Etching, aquatint, engraving and
drypoint on paper
1527 × 407 mm
P12263

PORTFOLIO TITLE
Lessons from the Russian
P12264–P12284 (complete)

[no title] 1999
Mezzotint and engraving
on paper
295 × 206 mm
P12265

[no title] 1999
Mezzotint and engraving
on paper
298 × 144 mm
P12266

[no title] 1999
Mezzotint and engraving
on paper
263 × 142 mm
P12267

[no title] 1999
Mezzotint and engraving
on paper
245 × 207 mm
P12268

[no title] 1999
Mezzotint and engraving
on paper
238 × 140 mm
P12269

[no title] 1999
Mezzotint and engraving
on paper
275 × 141 mm
P12270

[no title] 1999
Mezzotint and engraving
on paper
215 × 185 mm
P12271

[no title] 1999
Mezzotint and engraving
on paper
190 × 210 mm
P12272

[no title] 1999
Mezzotint and engraving
on paper
297 × 210 mm
P12273

[no title] 1999
Mezzotint and engraving
on paper
275 × 182 mm
P12274

[no title] 1999
Mezzotint and engraving
on paper
298 × 210 mm
P12275

[no title] 1999
Mezzotint and engraving
on paper
247 × 148 mm
P12276

[no title] 1999
Mezzotint and engraving
on paper
187 × 180 mm
P12277

[no title] 1999
Mezzotint and engraving
on paper
224 × 196 mm
P12278

[no title] 1999
Mezzotint and engraving
on paper
276 × 210 mm
P12279

[no title] 1999
Mezzotint and engraving
on paper
280 × 200 mm
P12280

[no title] 1999
Mezzotint and engraving
on paper
197 × 145 mm
P12281

[no title] 1999
Mezzotint and engraving
on paper
299 × 165 mm
P12282

[no title] 1999
Mezzotint and engraving
on paper
282 × 173 mm
P12283

[no title] 1999
Mezzotint and engraving
on paper
286 × 207 mm
P12284

Wind shift 1995
Lithograph and woodcut
on paper
471 × 315 mm
P12285

PORTFOLIO TITLE
inside weather
P12286–P12288 (incomplete)

any of which 1998
Monoprint, lithograph,
screenprint, collage and paint
on paper
508 × 1515 mm
P12286

as remembered 1998
Lithograph, screenprint, relief,
collage, stencil and paint on paper
533 × 1956 mm
P12287

could be 1998
Lithograph, screenprint, collage,
stencil and paint on paper
305 × 1092 mm
P12288

PORTFOLIO TITLE
long year
P12289 (incomplete)

facing 1992
Aquatint, etching, drypoint
and paint on paper
768 × 711 mm
P12289

PORTFOLIO TITLE
half light
P12290–P12308 (incomplete)

duty of water 1991
Etching, aquatint, mezzotint
and drypoint on paper
1007 × 809 mm
P12290

acting like ourselves 1991
Mezzotint and drypoint on paper
795 × 1003 mm
P12291

acting like ourselves, state I 1991
Mezzotint and paint on paper
813 × 1016 mm
P12292

acting like ourselves, state II 1991
Mezzotint on paper
797 × 1004 mm
P12293

coming going 1991
Mezzotint and drypoint on paper
803 × 1005 mm
P12294

coming going, state I 1991
Mezzotint and paint on paper
813 × 1016 mm
P12295

coming going, state II 1991
Mezzotint and drypoint on paper
803 × 1008 mm
P12296

dwarf of itself 1991
Mezzotint and drypoint on paper
1005 × 816 mm
P12297

dwarf of itself, state I 1991
Mezzotint and paint on paper
1016 × 838 mm
P12298

dwarf of itself, state II 1991
Mezzotint and drypoint on paper
1003 × 816 mm
P12299

dwarf of itself, state III 1991
Mezzotint and drypoint on paper
1007 × 816 mm
P12300

is was will be 1991
Mezzotint and drypoint on paper
1006 × 811 mm
P12301

is was will be, state I 1991
Mezzotint and paint on paper
1019 × 829 mm
P12302

is was will be, state II 1991
Mezzotint on paper
1002 × 811 mm
P12303

is was will be, state III 1991
Mezzotint and drypoint on paper
1005 × 811 mm
P12304

now then 1991
Mezzotint and drypoint on paper
1007 × 802 mm
P12305

now then, state I 1991
Mezzotint and paint on paper
1016 × 816 mm
P12306

now then, state II 1991
Mezzotint and drypoint on paper
1002 × 802 mm
P12307

now then, state III 1991
Mezzotint, drypoint and paint on
paper
1016 × 816 mm
P12308

those from away III 1989
Linocut and paint on paper
521 × 375 mm
P12309

those from away IV 1989
Linocut and paint on paper
521 × 464 mm
P12310

those from away V 1989
Linocut and paint on paper
584 × 584 mm
P12311

those from away VI 1989
Linocut and paint on paper
749 × 737 mm
P12312

those from away VII 1989
Linocut and paint on paper
1168 × 807 mm
P12313

Years and When 1985
Woodcut, relief, etching,
lithograph and collage on paper
1473 × 965 mm
P12314

Now At First and When 1985
Woodcut, relief, etching and
collage on paper
1683 × 1321 mm
P12315

difference in ages – iii 1998
Monotype, lithograph, mezzotint,
collage and paint on paper
464 × 406 mm
P12316

difference in ages – iv 1998
Monotype, lithograph, mezzotint,
collage and paint on paper
464 × 406 mm
P12317

rumors of virtue – IV 1993
Monoprint and collage on paper
419 × 406 mm
P12318

rumors of virtue – LXX 1993
Monoprint and collage on paper
419 × 406 mm
P12319

From Away 1988
Woodcut, lithograph, screenprint
and collage on paper on screen
1537 × 2057 × 305 mm
P12320

Frank Stella

Schwarze Weisheit #1 2000
Aquatint and lithograph on paper
845 × 621 mm
P12321

Schwarze Weisheit #2 2000
Aquatint and lithograph on paper
811 × 629 mm
P12322

Schwarze Weisheit #3 2000
Aquatint and lithograph on paper
803 × 618 mm
P12323

Schwarze Weisheit for D.J. 2000
Lithograph, etching, aquatint
relief and embossing on paper
1207 × 1016 mm
P12324

Stranz 1999
Screenprint on paper
1907 × 1056 mm
P12325

Nemrik 1999
Screenprint, relief, etching,
lithograph, engraving and stencil
on paper
1118 × 813 mm
P12326

Juam 1997
Relief, etching, aquatint,
lithograph, screenprint, woodcut
and engraving on paper
2375 × 1545 mm
P12327

Juam, State I 1997
Relief, woodcut, etching,
aquatint and paint on paper
1988 × 1524 mm
P12328

PORTFOLIO TITLE
Imaginary Places III
P12329–P12334 (incomplete)

Cantahar 1998
Lithograph, screenprint, etching,
aquatint and relief on paper
1330 × 1330 mm
P12329

Orofena 1998
Lithograph, screenprint, etching
and aquatint on paper
547 × 552 mm
P12330

Roncador 1998
Lithograph, screenprint, etching
and relief on paper
542 × 554 mm
P12331

Eusapia 1998
Lithograph, screenprint, etching
and relief on paper
553 × 553 mm
P12332

Iffish 1998
Lithograph, screenprint, etching,
aquatint, relief and engraving
on paper
556 × 536 mm
P12333

Aiolio 1998
Lithograph, screenprint, etching,
aquatint and relief on paper
545 × 722 mm
P12334

No Smoking (Large) 1998
Enamel on steel
721 × 595 mm
P12335

No Smoking (Small) 1998
Enamel on steel
721 × 595 mm
P12336

PORTFOLIO TITLE
Imaginary Places II
P12337–P12347 (incomplete)

Fattipuff 1996
Lithograph, screenprint, etching,
aquatint and relief on paper
812 × 816 mm
P12337

Fattiburg 1996
Lithograph, screenprint, etching,
aquatint, relief and engraving
on paper
813 × 813 mm
P12338

Dubiaxo 1996
Lithograph, screenprint, etching,
aquatint and relief on paper
737 × 737 mm
P12339

Jundapur 1996
Lithograph, screenprint, etching,
aquatint and relief on paper
737 × 737 mm
P12340

Sanor 1996
Lithograph, screenprint, etching,
aquatint, relief and engraving
on paper
697 × 677 mm
P12341

Bilbimtesirol 1996
Lithograph, screenprint, etching,
relief on paper
660 × 660 mm
P12342

Perinthia 1996
Lithograph, screenprint, etching,
aquatint and relief on paper
672 × 678 mm
P12343

Plutusia 1996
Lithograph, screenprint, etching,
aquatint, relief, mezzotint and
engraving on paper
665 × 660 mm
P12344

Atvatabar 1996
Lithograph, screenprint, etching,
aquatint and relief on paper
673 × 655 mm
P12345

Calnogor 1996
Etching, aquatint and relief
on paper
686 × 686 mm
P12346

Egyplosis 1996
Lithograph, etching, aquatint,
relief and screenprint on paper
654 × 654 mm
P12347

PORTFOLIO TITLE
Imaginary Places I
P12348–P12350 (incomplete)

Spectralia 1995
Lithograph, etching, relief,
aquatint, engraving and
screenprint on paper
686 × 831 mm
P12348

Feneralia 1995
Screenprint, lithograph, etching,
aquatint, relief and collagraph
on paper
1168 × 1067 mm
P12349

Libertinia 1995
Relief, screenprint, etching,
aquatint, lithograph and
engraving on paper
1257 × 557 mm
P12350

PORTFOLIO TITLE
Moby Dick Deckle Edges
P12351–P12353 (incomplete)

A Bower in the Arsacides 1993
Lithograph, etching, aquatint,
relief and collagraph on paper
1480 × 1261 mm
P12351

The Affidavit 1993
Lithograph, etching, aquatint,
relief and screenprint on paper
1565 × 1151 mm
P12352

The Whale-Watch 1993
Lithograph, etching, aquatint
and relief on paper
2232 × 1836 mm
P12353

PORTFOLIO TITLE
Moby Dick Domes
P12354 (incomplete)

Jonah Historically Regarded
(Dome) 1992
Etching, aquatint, relief,
engraving, screenprint, stencil
and paint on paper
1867 × 1346 mm
P12354

PORTFOLIO TITLE
Moby Dick Engravings
P12355–P12358 (incomplete)

The Cabin. Ahab and Starbuck
1991
Etching, aquatint and relief
on paper
1896 × 1337 mm
P12355

The Fossil Whale 1991
Etching, aquatint and relief
on paper
1899 × 1372 mm
P12356

Stubb & Flask kill a
Right Whale 1991
Etching, aquatint and relief
on paper
1937 × 1365 mm
P12357

The Funeral 1991
Etching, aquatint, relief and
drypoint on paper
1988 × 1511 mm
P12358

Bene come il sale 1989
Etching, aquatint and relief
on paper
1940 × 1508 mm
P12359

Bene come il sale, State I 1989
Etching, aquatint and relief
on paper
1937 × 1507 mm
P12360

Bene come il sale, State IV 1989
Etching, aquatint and relief
on paper
1935 × 1496 mm
P12361

Giufà e la berretta rossa 1989
Etching, aquatint, relief and
engraving on paper
1965 × 1435 mm
P12362

Green Journal 1985
Etching, screenprint and relief
on paper
1680 × 1330 mm
P12363

PORTFOLIO TITLE
Circuit Series
P12364–P12366 (incomplete)

Talladega Three III 1982
Relief on paper
1680 × 1318 mm
P12364

Talladega Five I 1982
Relief and woodcut on paper
1680 × 1305 mm
P12365

Imola Three I 1982
Relief and engraving on paper
1677 × 1305 mm
P12366

PORTFOLIO TITLE
Swan Engraving Series
P12367–P12369 (incomplete)

Swan Engraving I 1982
Etching on paper
1667 × 1285 mm
P12367

Swan Engraving II 1982
Etching on paper
1678 × 1315 mm
P12368

Swan Engraving IV 1982
Etching and relief on paper
1653 × 1303 mm
P12369

Altoon Sultan

Dairy Cows, North Danville,
Vermont 1992
Drypoint, aquatint and
watercolour on paper
489 × 965 mm
P12370

Spring Clouds, Ojai, California
1992
Drypoint and watercolour
on paper
489 × 654 mm
P12371

Red Roofs, North Island,
New Zealand 1990
Drypoint and watercolour
on paper
686 × 946 mm
P12372

House and Hill, North Island,
New Zealand 1990
Drypoint and watercolour
on paper
432 × 680 mm
P12373

Donald Sultan

Four Red Flowers May 17 1999
1999
Woodcut on paper
711 × 914 mm
P12374

Blue Flowers May 19 1999
1999
Woodcut on paper
711 × 914 mm
P12375

Black Flowers Sept 26 1999
1999
Woodcut on paper
711 × 914 mm
P12376

Six Red Flowers Oct 28 1999
1999
Woodcut on paper
711 × 914 mm
P12377

Black Eggs and Roses May 22 2000
2000
Relief and woodcut on paper
1727 × 1753 mm
P12378

PORTFOLIO TITLE
The Album Series
P12379–P12382 (incomplete)

Eight Ball Feb 14 1996 1996
Lithograph, woodcut and etching
on paper
1073 × 743 mm
P12379

Orange Feb 27 1996 1996
Lithograph, woodcut and
etching on paper
1073 × 743 mm
P12380

Button March 1 1996 1996
Lithograph, woodcut and
etching on paper
1073 × 743 mm
P12381

Butterfly Feb 26 1996 1996
Screenprint, relief, embossing
and paint on paper
1073 × 743 mm
P12382

Masami Teraoka

Longing Samurai 1993
Woodcut, etching and aquatint
on paper
648 × 972 mm
P12383

View From Here to Eternity 1993
Woodcut, etching, aquatint
and paint on paper
648 × 972 mm
P12384

Catfish Envy 1993
Woodcut, etching, aquatint
and paint on paper
680 × 978 mm
P12385

Kunisada Eclipsed 1993
Woodcut, etching, aquatint
and paint on paper
660 × 1156 mm
P12386

Jack Tworkov

KTL #1 1982
Lithograph on paper
699 × 699 mm
P12387

John Walker

The Witness 1999
Etching, aquatint and paint
on paper
559 × 406 mm
P12388

A Terre 1999
Etching, aquatint, drypoint and
monotype on paper
470 × 362 mm
P12389

The Studio 1999
Etching, aquatint, engraving and
paint on paper
464 × 362 mm
P12390

Flanders 1999
Etching, aquatint and engraving
on paper
470 × 362 mm
P12391

Repose 1999
Etching, monotype and stencil
on paper
467 × 365 mm
P12392

Mount Kisco Studio 1996
Woodcut on paper
927 × 775 mm
P12393

Mount Kisco Studio, State I 1996
Woodcut on paper
927 × 775 mm
P12394

Mount Kisco Studio, State II 1996
Woodcut on paper
927 × 775 mm
P12395

Sheep Skull I 1998
Etching and aquatint on paper
419 × 648 mm
P12396

Sheep Skull II 1998
Etching and aquatint on paper
419 × 648 mm
P12397

The Somme 1998
Etching and aquatint on paper
660 × 422 mm
P12398

The Somme, State I 1998
Etching and aquatint on paper
660 × 422 mm
P12399

PORTFOLIO TITLE
Passing Bells
P12400–P12410 (incomplete)

Page 1, State I 1998
Etching on paper
467 × 362 mm
P12400

Page 5, State I 1998
Etching on paper
467 × 362 mm
P12401

Page 6, State I 1998
Etching on paper
467 × 362 mm
P12402

Page 9, State I 1998
Etching on paper
467 × 362 mm
P12403

Page 10, State I 1998
Etching on paper
467 × 362 mm
P12404

Page 16, State I (Brown) 1998
Etching on paper
467 × 362 mm
P12405

Page 16, State I (Black) 1998
Etching on paper
467 × 362 mm
P12406

Page 18, State I 1998
Etching on paper
467 × 362 mm
P12407

Page 19, State I 1998
Etching on paper
467 × 362 mm
P12408

Page 24, State I 1998
Etching on paper
467 × 362 mm
P12409

Page 25, State I 1998
Etching on paper
467 × 362 mm
P12410

PORTFOLIO TITLE
Passing Bells
P12411–P12437 (complete)

[no title] 1998
Etching on paper
467 × 362 mm
P12411

[no title] 1998
Etching on paper
467 × 362 mm
P12412

[no title] 1998
Etching on paper
467 × 362 mm
P12413

[no title] 1998
Etching on paper
467 × 362 mm
P12414

[no title] 1998
Etching on paper
467 × 362 mm
P12415

[no title] 1998
Etching on paper
467 × 362 mm
P12416

[no title] 1998
Etching on paper
467 × 362 mm
P12417

[no title] 1998
Etching on paper
467 × 362 mm
P12418

[no title] 1998
Etching on paper
467 × 362 mm
P12419

[no title] 1998
Etching on paper
467 × 362 mm
P12420

[no title] 1998
Etching on paper
467 × 362 mm
P12421

[no title] 1998
Etching on paper
467 × 362 mm
P12422

[no title] 1998
Etching on paper
467 × 362 mm
P12423

[no title] 1998
Etching on paper
467 × 362 mm
P12424

[no title] 1998
Etching on paper
467 × 362 mm
P12425

[no title] 1998
Etching on paper
467 × 362 mm
P12426

[no title] 1998
Etching on paper
467 × 362 mm
P12427

[no title] 1998
Etching on paper
467 × 362 mm
P12428

[no title] 1998
Etching on paper
467 × 362 mm
P12429

[no title] 1998
Etching on paper
467 × 362 mm
P12430

[no title] 1998
Etching on paper
467 × 362 mm
P12431

[no title] 1998
Etching on paper
467 × 362 mm
P12432

[no title] 1998
Etching on paper
467 × 362 mm
P12433

[no title] 1998
Etching on paper
467 × 362 mm
P12434

[no title] 1998
Etching on paper
467 × 362 mm
P12435

[no title] 1998
Etching on paper
467 × 362 mm
P12436

[no title] 1998
Etching on paper
467 × 362 mm
P12437

Robert Rahway Zakanitch

Double Geese Mountain 1981
Screenprint, lithograph and
stencil on paper
692 × 572 mm
P12438

Further Reading

Compiled by Federica Panicieri

TYLER GRAPHICS

Art off the Picture Press: Tyler Graphics Ltd, The Emily Lowe Gallery, Hofstra University, New York 1977

Biennale di Venezia, XLIII Edizione, Padiglione Norvegia, Svezia e Finlandia: *Rolf Hanson, Per Inge Biørlo, Jukka Mäkelä*, Venice 1988

Graphic Vision, Kenneth Tyler Retrospective Exhibition: Thirty Years of Contemporary American Prints, Centre for Contemporary Graphic Art and Tyler Graphic Archive Collection, Fukushima 1995

Seven Master Printmakers, Innovation in the Eighties, Museum of Modern Art, New York 1991

The Art of Collaboration, The Big Americans, National Gallery of Australia, Canberra 2002

Tyler Graphics: Catalogue Raisonné, 1974–1985, Abbeville Press, New York 1987

Tyler Graphics: The Extended Images, Abbeville Press, New York 1987

Gilmour P., *Ken Tyler – Master Printer and the American Print Renaissance*, The Australian National Gallery, Canberra 1986

Ken Tyler, 25 Glorious Years, Heland Wetterling Gallery, Stockholm 1989

CATALOGUES AND BOOKS
Alphabetical by artist

Ed Baynard, *Woodblock Prints and Watercolored Lithographs* 1980, Tyler Graphics Ltd., New York 1980

Per Inge Bjørlo, *Om alle pedagoger, terapeuter og pasienter var tause/ sirkelens kvadratiske begrensning. If all the pedagogues, therapists and patients were mute/ the square delimitation of the circle*, Lillehammer Kunstmuseum, Lillehammer 1996

Per Inge Bjørlo, *Heads from Balance*, Tyler Graphics Ltd., New York 1998

Stanley Boxer, *Ring of Dust in Bloom*, Tyler Graphics Ltd., New York 1976

Stanley Boxer, *Carnival of Animals*, Tyler Graphics Ltd., New York 1979

William Crutchfield, *Five trains and Zeppelin Island*, Tyler Graphics Ltd, New York 1978

Helen Frankenthaler, *Prints; 1961–1979*, The Williams College Artists-in-Residence Program, Harper & Row, New York 1980

Helen Frankenthaler Prints, National Gallery of Art, Washington 1993

Harrison P., Boorsch S., *Frankenthaler, A Catalogue Raisonné, Prints 1961–1994*, Harry N. Abrams Inc., New York 1996

David Hockney, *23 Lithographs 1978–1980*, Tyler Graphics Ltd., New York 1980

Ashton D., *Terence La Noue*, Hudson Hills Press, New York 1992

Roy Lichtenstein, *Entablature Series, a group of eleven graphics printed and published by Tyler Graphics Ltd*, Tyler Graphics Ltd., New York 1976

Joan Mitchell, *Bedford Series*, Tyler Graphics Ltd., New York 1981

Joan Mitchell, *The Presence of Absence*, Cheim & Read, New York 2002

Malcom Morley, *In Full Color*, Hayward Gallery, London 2001

Engberg S., Banach J., *Robert Motherwell, The Complete Prints 1940–1991, Catalogue Raisonné*, Walker Art Center, Minneapolis 2003

John Newman, *On the other hand, Sculpture Multiples – Second Thoughts, Print Series*, Tyler Graphics Ltd., New York 1995

James Rosenquist, *Welcome to the Water Planet and House of Fire 1988–1989*, Tyler Graphics Ltd., New York 1989

James Rosenquist, *Time Dust*, Tyler Graphics Ltd., New York 1992

James Rosenquist, *A retrospective*, Solomon R. Guggenheim Museum, New York 2003

David Salle, *High and Low*, Tyler Graphics Ltd., New York 1994

Alan Shields: Images in Paper, Centre for Contemporary Art and Tyler Graphics Archive Collection, Fukushima 1998

Alan Shields, The Beach Museum of Art, Kansas State University, Manhattan 1999

Richard Smith, *Cartouche Series*, Norman Mackenzie Art Gallery, University of Regina, Regina 1980

Steven Sorman, *Collage Prints and Monoprints*, Tyler Graphics Ltd., New York 1985

Steven Sorman, *Vignette*, University of Missouri-Kansas City Gallery of Art and Tyler Graphics Ltd., 1989

Steven Sorman, *Rumors of Virtue*, Tyler Graphics Ltd., New York 1993

Frank Stella at Tyler Graphics, Walker Art Center, Minneapolis 1997

Frank Stella, The Prints, A Catalogue Raisonné 1967–1982, The University of Michigan Museum of Art, Ann Arbor 1983

Masami Teraoka, *Hawaii Snorkel Series*, Tyler Graphics Ltd., New York 1993